P9-BZH-961

CRUMBLE.CRACKLE.BURN.

120 stunning textures for design and illustration

dvd includes hi-res image files, photoshop brushes and bonus textures **VON GLITSCHKA**

HOW BOOKS
Cincinnati, Ohio
www.howdesign.com

ABOUT THE AUTHOR

Von Glitschka has worked in the communication arts industry for twenty years as a senior designer and art director. His fresh, exuberant graphics—for both in-house art departments and medium to large creative agencies—have won numerous design and illustration awards along the way.

In 2002, Von started Glitschka Studios, a multi-disciplinary creative agency. His clients include General Motors, Microsoft, Pepsi, Virgin Atlantic, Hasbro, Bandai Toys, Edison Power, Allstate Insurance and Upper Deck.

Along with illustrative design work, Von pursues a large number of other design interests. Von frequently speaks at design associations and colleges. His current presentation, "The Illustrative Designer—Creative Process," will soon become a podcast. Von teaches digital illustration at a local college, and has created www.illustrationclass.com, a resource site for students and professionals alike. Visit him at www.glitschka.com.

DEDICATION

To the one whose portfolio trumps everyone: Jesus Christ. From the human smile to the intricate patterns on a tropical fish, He is the ultimate designer, inspiration and one true source of my creativity and ability. My desire is to honor Him with my artwork and let His creativity never cease to inspire me.

To my wife, Rebecca, who puts up with a temperamental artist and is the balancing factor in my life. I love you.

To my daughters, Savannah and Alyssa. You two constantly remind me that life should be filled with curious thoughts, playing, laughing and simple faith. I am inspired by you both more than you'll ever know, and I enjoy watching you grow into beautiful young women. Remember, keep drawing.

To my family and friends. You've put up with my doodles, bad jokes and goofy stories, and I thank you for your support and friendship over the years.

CRUMBLE.CRACKLE.BURN. Copyright © 2007 by Von Glitschka. Manufactured in China. All rights reserved. No other part of this book may be reproduced in any form or by any electronic or mechanical means including information storage and retrieval systems without permission in writing from the publisher, except by a reviewer, who may quote brief passages in a review. Published by HOW Books, an imprint of F+W Publications, Inc., 4700 East Galbraith Road, Cincinnati, Ohio 45236. (800) 289-0963. First edition.

11 10 09 08 07 5 4 3 2 1

Distributed in Canada by Fraser Direct, 100 Armstrong Avenue, Georgetown, Ontario, Canada L7G 5S4, Tel: (905) 877-4411. Distributed in the U.K. and Europe by David & Charles, Brunel House, Newton Abbot, Devon, TQ12 4PU, England, Tel: (+44) 1626 323200, Fax: (+44) 1626 323319, E-mail: postmaster@davidandcharles.co.uk. Distributed in Australia by Capricorn Link, P.O. Box 704, Windsor, NSW 2756 Australia, Tel: (02) 4577-3555.

Library of Congress Cataloging-in-Publication Data
Glitschka, Von.
 Crumble crackle burn : 60 stunning textures for design and illustration / by Von Glitschka. -- 1st ed.
 p. cm.
 Includes index.
 ISBN-13: 978-1-58180-958-9 (hardcover with dvd : alk. paper)
 ISBN-10: 1-58180-958-1
 1. Texture (Art) I. Title.
 N7430.5.G58 2007
 745.4--dc22 2006034854

Edited by: Amy Schell
Designed by: Grace Ring
Production coordinated by: Greg Nock

TABLE OF CONTENTS

TEXTURES

TEXTURE EXPLORING

HOW DID IT BEGIN?

It was my first year of art school back in 1985. I had a photography class, and our assignment was to go out and shoot downtown Seattle. At first I started taking the garden-variety pictures of the Pike Place Market and Space Needle. One day, walking to the art store, my route went by a boarded-up hotel. The look of the place intrigued me. It was literally decaying: paint chipping away, broken windows and crumbling cement walls. A "No Trespassing" sign was stapled to the plywood sheets blocking the front entrance.

In many ways, the choice I made that day was a turning point in my creative process. I ditched my plans to capture scenes of Seattle. Instead, I decided to take creative license with the assignment. Climbing over the boarded-up doorway, I entered the abandoned hotel. There before me was a whole new world of cool surface textures. Crumbling paint. Dusty paneling. Stained wallpaper. Rusted metal.

I lost track of time. I spent hours in that decrepit hotel, moving my tripod from place to place, and

capturing a variety of texture references. At one point, I even reclined on the floor and took a picture of the peeling ceiling.

I can't remember the grade I got for that assignment. I don't remember all my classmates' names. But I'll never forget the joy of discovering something new and significant. That day, I developed a lifelong fascination with what I later learned was the second law of thermodynamics: entropy. (More about this later).

Over the next two years of art school, I often took my scooter and went texture exploring. Simply put, this meant driving around looking for interesting textures, and taking photos. Of course, back then, digital wasn't even an option for art or photography. I had to shoot rolls of film and then pay for development. Being a poor art student, I couldn't collect and use textures as much as I would've liked. But I still searched the city for cool and unusual textures, and began using them in my art.

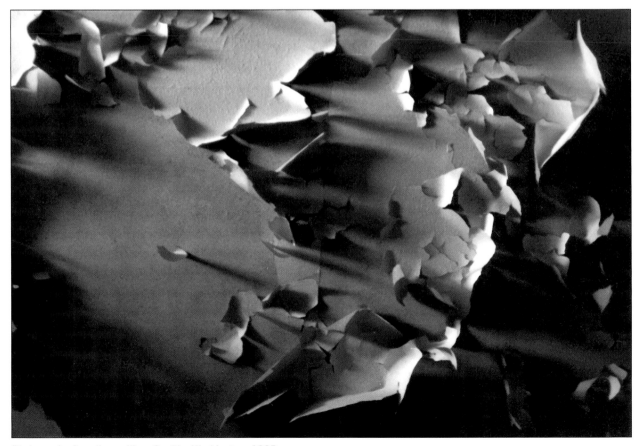

Photograph of peeling ceiling. Seattle, Washington, 1985.

WHAT IS IT?

Texture exploring is simply hunting for textures, then capturing them on film or digitally, so you can use them in your design and illustration projects.

When I first starting texture exploring, it was much more difficult. We didn't have editing software, external hard drives or memory cards. You had to wait to get film developed. Fast forward to the present, and designers now have digital cameras. Constraints such as film development costs, turnaround time, and organizing your collection are no longer issues. Early digital cameras didn't have high enough resolutions, but when the five megapixel barrier was broken, I switched to digital for all my texture exploring.

Ever since I started my own design and illustration studio, I've made texture hunting part of my routine. And in the past four years, I've captured textures all over America. Nearly every day I spot one. If I don't have my camera, I note the spot and revisit it later. Just this morning, walking through the standard urban parking lot, my eye was drawn to a huge, worn arrow painted on the asphalt. It was a very unique texture. I didn't have my camera, but I'll go back tomorrow. Textures aren't camera-shy or elusive, and they don't roam the Serengeti in herds.

You can almost always track them down again and take photos later if needed. I usually write down prime locations so I don't forget.

If you want success in texture exploring, you have to plan your attack. I go hunting based on the potential for cool textures. High on this list are industrial areas, abandoned factories, old vacant houses, metal warehouses and the Holy Grail of disrepair—junkyards. But be alert: You'll be surprised how many amazing surfaces are hiding away at mundane places like parking garages or loading docks. Because planning is helpful, sometimes I drive by a potential location, scout it out, and then revisit it later to harvest the cool textures.

I even get my two daughters involved. They enjoy going texture exploring. For them, it's like a treasure hunt. Having an artistic and creative dad means they've spent time crawling around rickety boxcars, driving out to old country barns, and wandering through junkyards. My girls often point out textures that I missed. They even tell me about the ones they saw during their day. From time to time, my wife helps out. It's become a fun little activity we do together. I guess we're the Family Von Trapp of the texture world … without the lederhosen, of course.

HOW DO YOU DO IT?

My methodology and approach for texture exploring isn't ironclad. But I'll give you tips on how to start assembling your own cool texture collection. Study the textures on the DVD to get an idea of what works. But once you begin capturing images and using them in your art, you'll also discover new methods of your own. Creativity comes from figuring out how to customize the texture exploring process with your own work flow and preferences. Here are a few of my tips.

- *Invest in a good digital camera.* Get a digital camera with at least five megapixels.

- *Use a tripod or monopod.* Essential for sharp photos. It's no good capturing images if they turn out blurry.

- *Bring lots of memory.* Purchase the most memory for your camera that you can afford. I use a large memory stick that allows up to 100 hi-res pictures without running out of room. I also keep a few smaller memory sticks as backups. You can never have too much memory, and you want to take your shots at the highest quality setting possible.

- *Plan your exploration.* Decide in advance what location you'll be exploring. Scout it out if possible. Get permission if necessary.

- *Walk.* You can drive to the chosen location, but then take time to walk the site. Walking will help you notice subtle textures. On foot you'll discover things you'd miss in a moving car.

- *Not sure? Shoot it!* Not sure if a texture will work or look good? Shoot it anyway. Sometimes a texture looks better inverted than it does in its original format. Sometimes what looks poor on the little LCD screen turns out to be fantastic. Make your editing decisions later.

- *Have fun.* It's amazing what you'll discover when you start poking around in places. Sometimes people give me weird looks because I'm kneeling before a cement wall. I'm sure they're puzzled— here I am, pointing the camera at what they think is just a cement wall. In actuality, it's a stinkin' cool texture I plan on using in my artwork. Have fun with the process, and enjoy the strange stares while you're pursuing your treasures.

- *Archive and catalog right away.* I use iPhoto on a Macintosh computer, but you can use any variety of software that allows you to organize your pictures and create categories. I assign keywords to my images when I import them. Don't wait, or you'll never add keywords. Also, organize your images into texture categories (such as Wood, Cement, Metal). This will make it easier to manage your texture catalog in the long run. Nothing is worse than having to scroll through two thousand hi-res images trying to find the crackled paint you shot at a shipyard two years ago.

- *Fine-tune final results.* Take your captured texture image into Photoshop and tweak away. You can improve contrast, sharpen the image and much more. A little adjustment and imagination in an image editor will open up all kinds of options for you creatively. I have my own method for creating the textures in this book. But this is not a "How-To" book; it's a "Go-Do" book. So I won't spend time telling you how to make textures—instead, grab the texture DVD, stick it in your machine and start creating.

WHAT IS ENTROPY?

Entropy is the wellspring of amazing textures. It is the inevitable and steady deterioration of a system or society. Entropy is part of the second law of thermodynamics. And for all the cool textures you'll discover while texture exploring, entropy is the source.

For some reason, entropy itself is still going strong after all these years, and seems to be immune itself from the forces of entropy. That will have to be the subject of another book. Meanwhile, enjoy these sixty textures, and have fun adding organic and tactile flavor to your design and illustration projects.

INTRODUCTION

The communication arts industry has been invaded. We've been inundated and overrun by computer-driven artwork and design. Vector and bit-map art have taken over—and they're here to stay. It's partly because older technology and methods fell short. Pen, ink, letterpress, brushes, films, screens—they didn't always deliver constancy. There were unexpected blemishes and variations. So now we have software-centric design, producing flawless content. But the digital revolution has its downside.

Frankly, today's artwork and design often looks too clean, too exact. One might even say sterile. Intentional or not, the computer emits precise work. We've become like the modern apple, perfectly red, shiny and smooth... but tasteless. So much of modern digital design seems bred for a perfect mediocrity.

How can we create art and design that escapes uniformity? Maybe you've wondered how to successfully capture the feel of a well-worn printed piece. Or how to add an organic flair to your art—without it looking obviously grunged up by software. How do designers and illustrators achieve that authentic, created-by-hand look?

The answer is textures.

If there is one aspect to design that is timeless, it is texture. A real-world texture looks just as authentic now as it will in one hundred years. That's because it's not created by a person sitting at a computer. Textures are natural, or are by-products of natural elements interacting with man-made edifices and structures. Creatives can take these authentic, raw patterns, and apply them to design and illustration. Using textures, you can break free from the clean and crisp look of computer-driven art, and enter a realm of delectable decay and depth.

This book comes with sixty high-resolution, real-world textures to use in your creative pursuits (plus sixty bonus textures on the DVD). Nothing is pre-fab or digitally created. All texture content comes straight from the source—natural settings, industrial wastelands, lonely city streets, and other areas of subtle beauty and decline. I've only packaged the textures for easy access and usage, via the most common formats creative professionals use. This book and companion DVD will save you time and allow you to focus on the creative process, without having to brave dark alleys, abandoned factories or empty parking garages.

Along with the textures, this book showcases actual artwork, using each of the sixty texture files. Individual artists were given an assigned texture to use in a project. The resulting art demonstrates just a tiny portion of the range of possibilities in design and illustration techniques. Let their examples inspire you to create and use these textures for your own creative pursuits.

Dig in! Textures are raw resources. The motive for this book is to see you customize them to your own work. Adapt them, play with them, deconstruct them in projects. Sure, you can simply place the images in your art or design, and come up with good results. But you'll get more—and see the endless possibilities—when you experiment on your own. You'll discover a new visual voice for your work. And that is a whole lot of fun.

I warn you—texture usage can lead to addictive tendencies. The more you use textures, the more you'll want to keep using textures. You'll catch yourself thinking how cool the family portrait would look with a subtle crackle pattern. Soon you'll go texture exploring yourself. Your friends and family will roll their eyes as you plead, "Hang on, just one more shot of this exquisite dry rot!"

Computer design is too clean and crisp. I'm leading a rebellion against the sterile. It's time to add texture to all your art!

TEXTURE:
Woodn't It Be Nice

SOURCE:
old barn door

Animals no longer call this barn home. It sits in the midst of tall country prairie grass, and like a farmer's weathered face, it speaks wearily of wind, heat and dust.

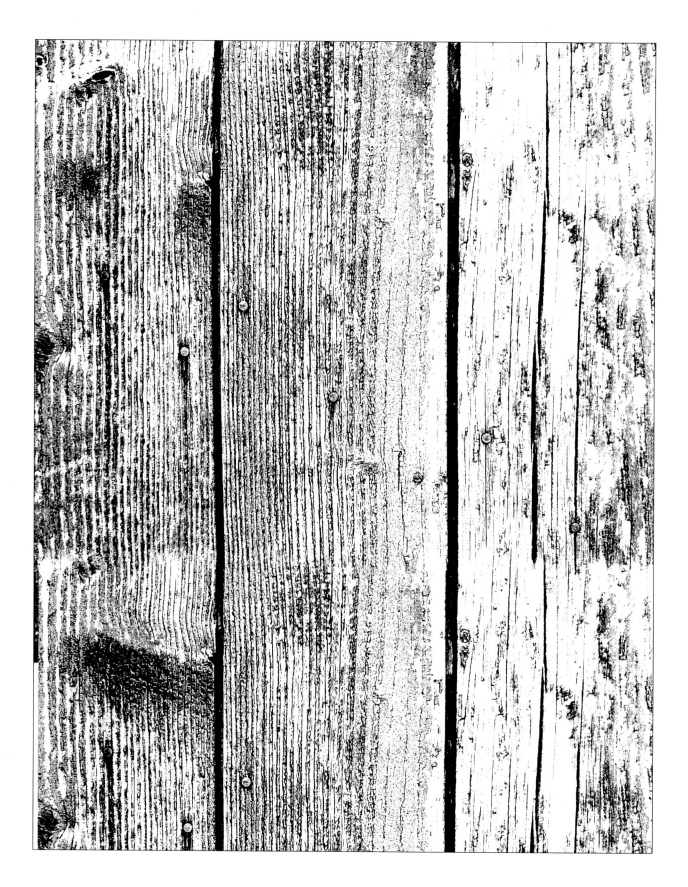

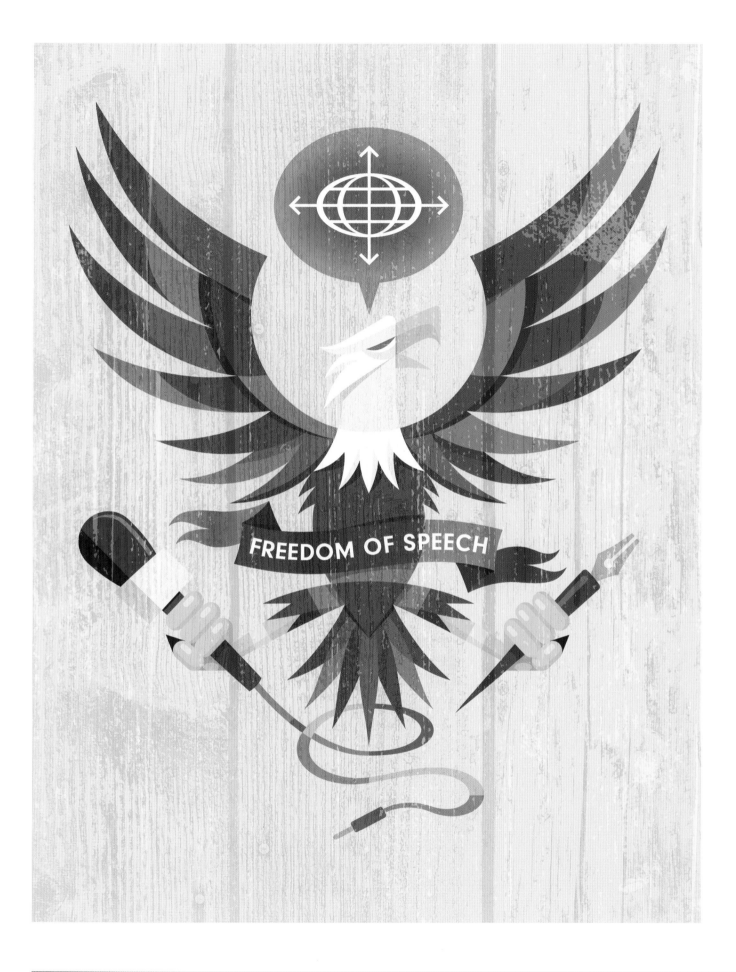

"FREEDOM OF SPEECH" Created by Von R. Glitschka. Copyright © 2006.

TEXTURE: **SOURCE:**
Eroding Foundation bridge foundation

Cars and people traverse this structure all day long. They are unaware of the magnum opus of textures quietly eroding away on its decaying base. It's one of nature's masterpieces of oxidation.

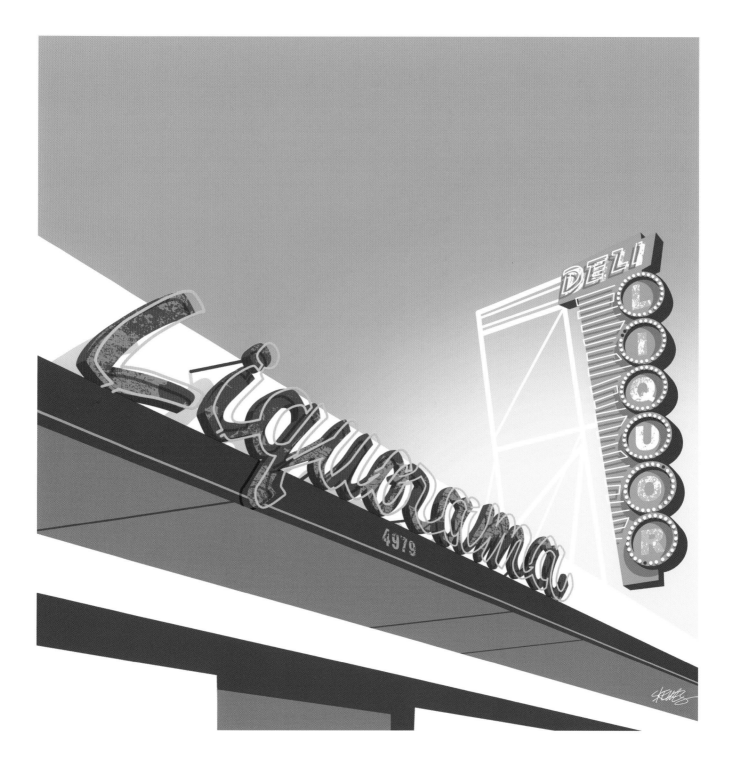

"LIQUORAMA LIQUOR STORE, LOS ANGELES" Created by John Skewes. Copyright © 2006.

TEXTURE:
Monumental Decay

SOURCE:
park statue

Even honor, fame and eternal gratitude couldn't protect this fallen hero's statue from the attack of time.

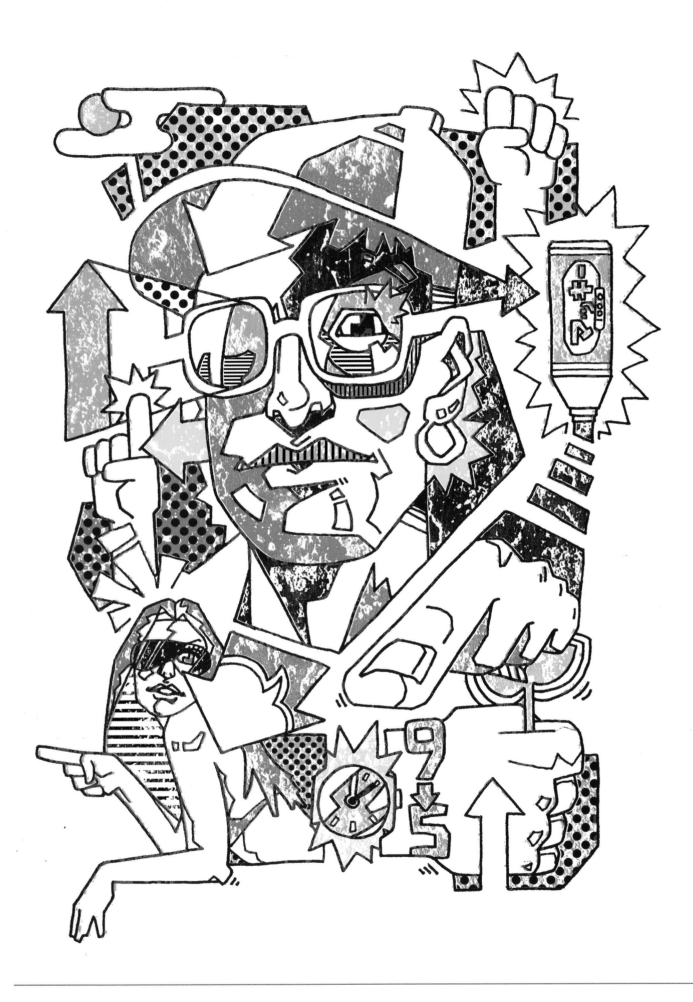

"DOUGLAS' GLASSES" Created by Junichi Tsuneoka. Copyright © 2006.

TEXTURE:
Boxcar Willy 1

SOURCE:
boxcar

Parked on the wrong side of the tracks, a vacant shell of metal is now home for forgotten societies. You would definitely not say this train is bound for glory.

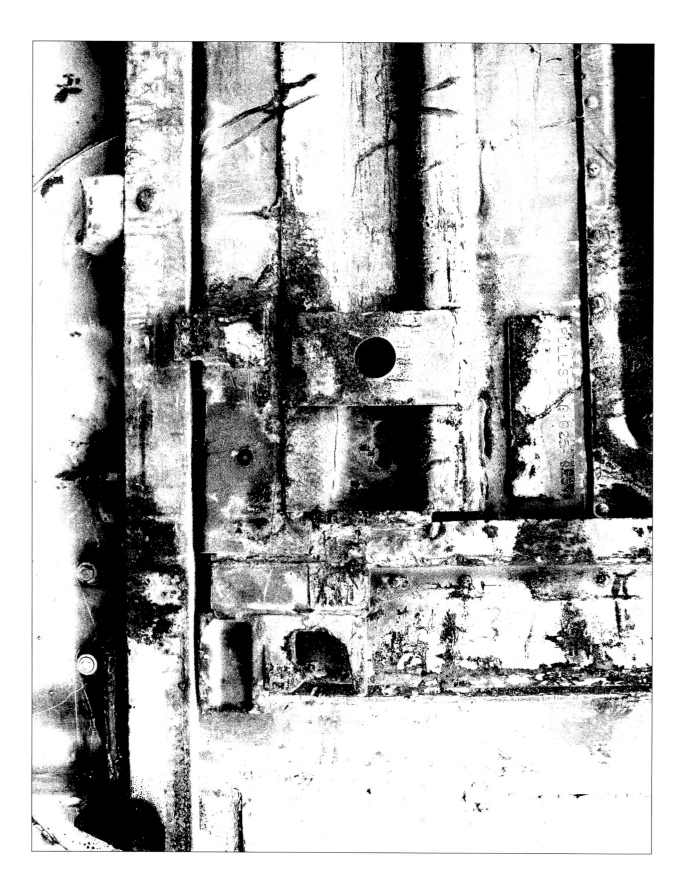

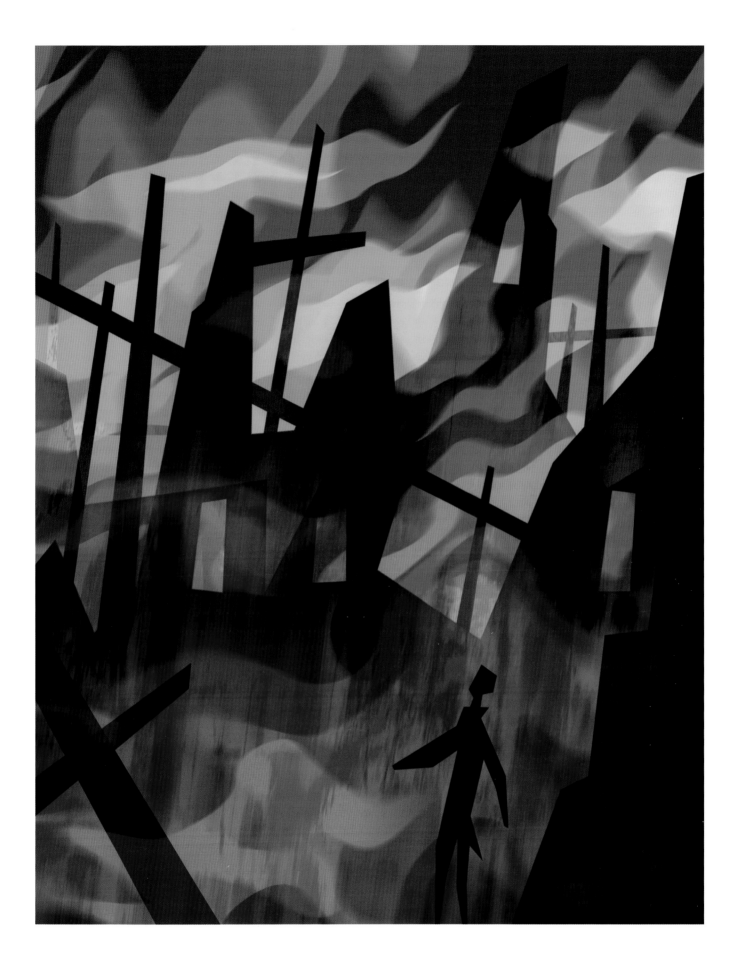

"THE FIRE" Created by Lou Romano. Copyright © 2006.

TEXTURE:
Wearhouse

SOURCE:
warehouse

The contents of this structure hold all kinds of goods ready to ship out on trucks. As boxes and boxes of shiny new products arrive at the warehouse, the glorious decomposition on the humble loading dock sits unnoticed.

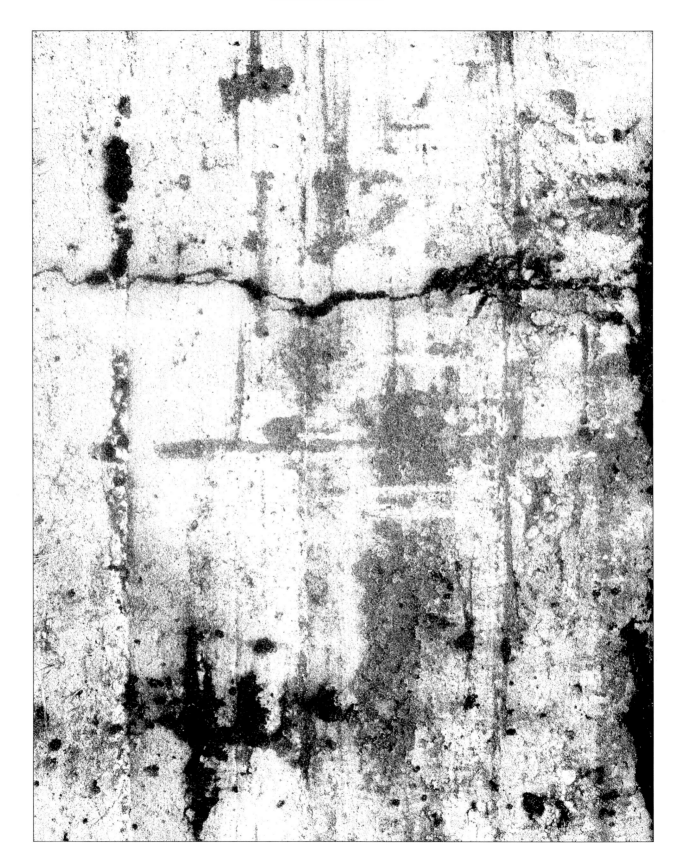

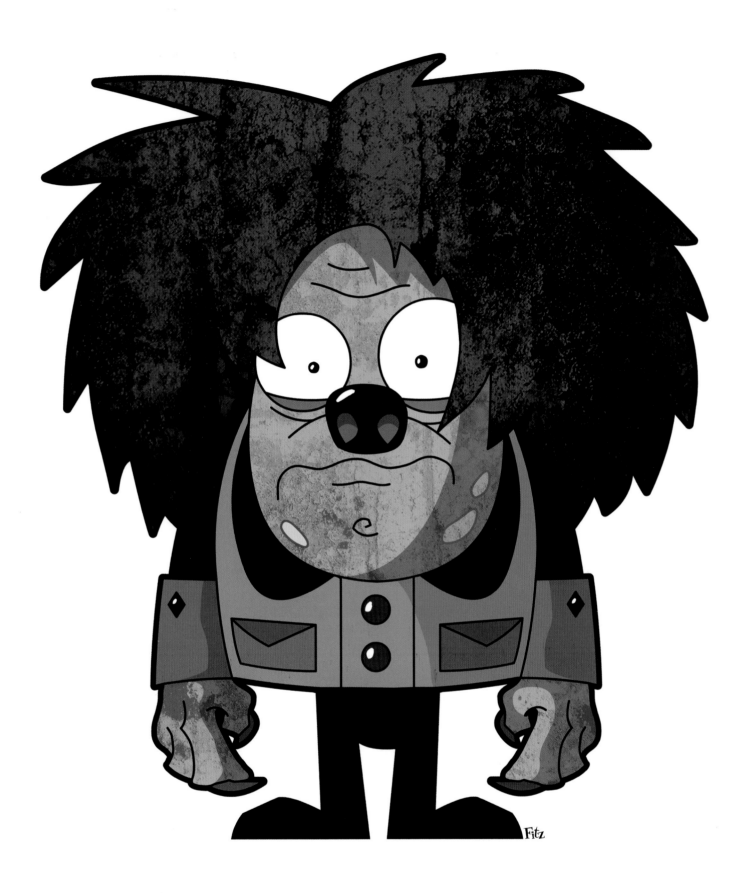

"BYRNE" Created by Brad Fitzpatrick. Copyright © 2006.

TEXTURE:
Moses' Lost Tablet

SOURCE:
concrete slab

Orphaned in an industrial district alley, this chunk of wall looks like it was built in the days of the prophets. It might be a fitting place to inscribe the Eleventh Commandment, "Thou shalt distress and add texture to thy projects."

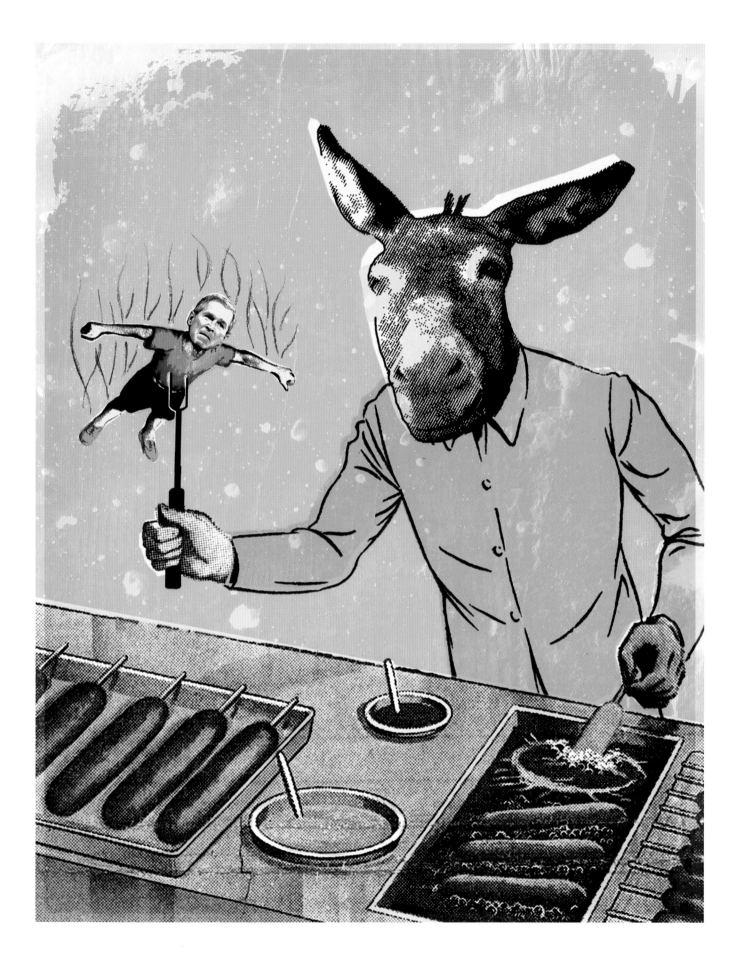

"TEXAS BBQ" Created by Dotzero Design. Copyright © 2006.

TEXTURE:
Scraped Ribs

SOURCE:
corrugated siding

Sometimes getting rubbed the wrong way is a good thing. At least that's what I thought when I found this deliciously distressed structure.

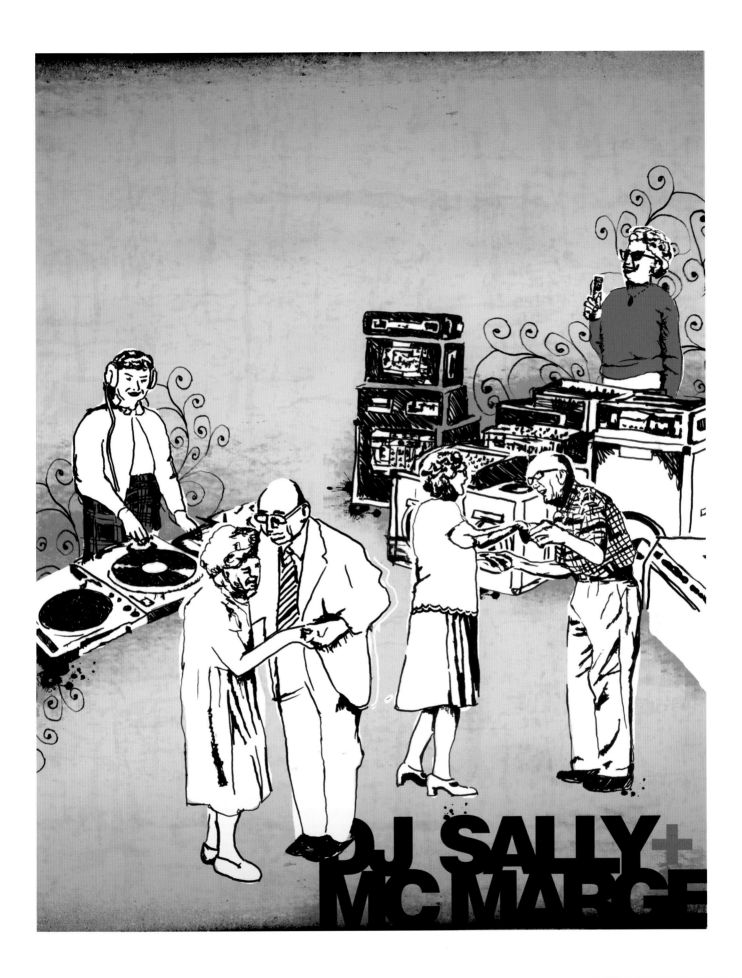

"DJ SALLY AND MC MARGE ROCK THE LOCAL V.F.W." Created by Ty Burrowbridge. Copyright © 2006.

TEXTURE:
Concrete Acne

SOURCE:
concrete wall

Pock marks and scarring make up the dermatological character of this edifice. Who knew blemishes could actually be artistic?

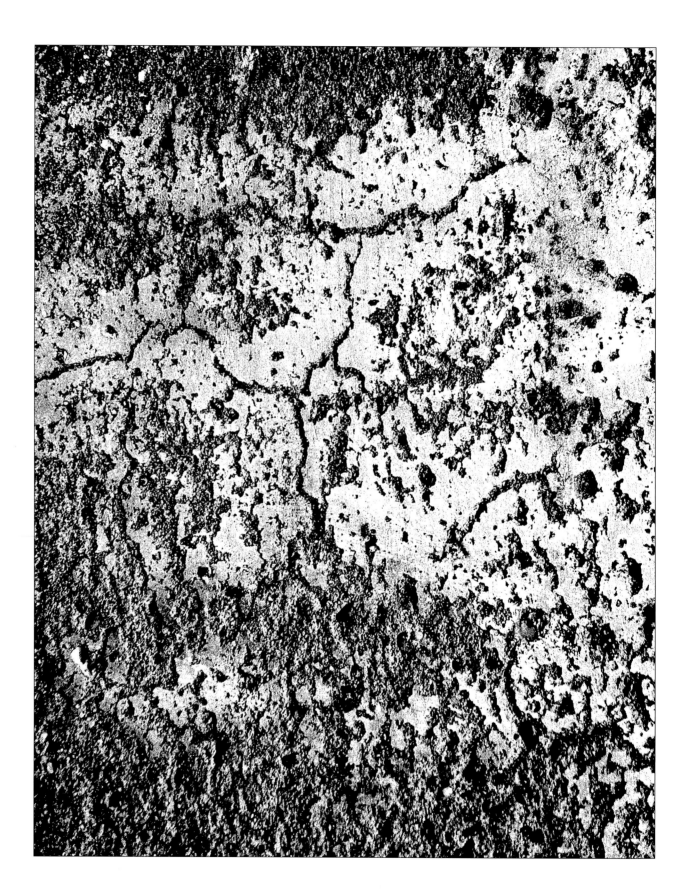

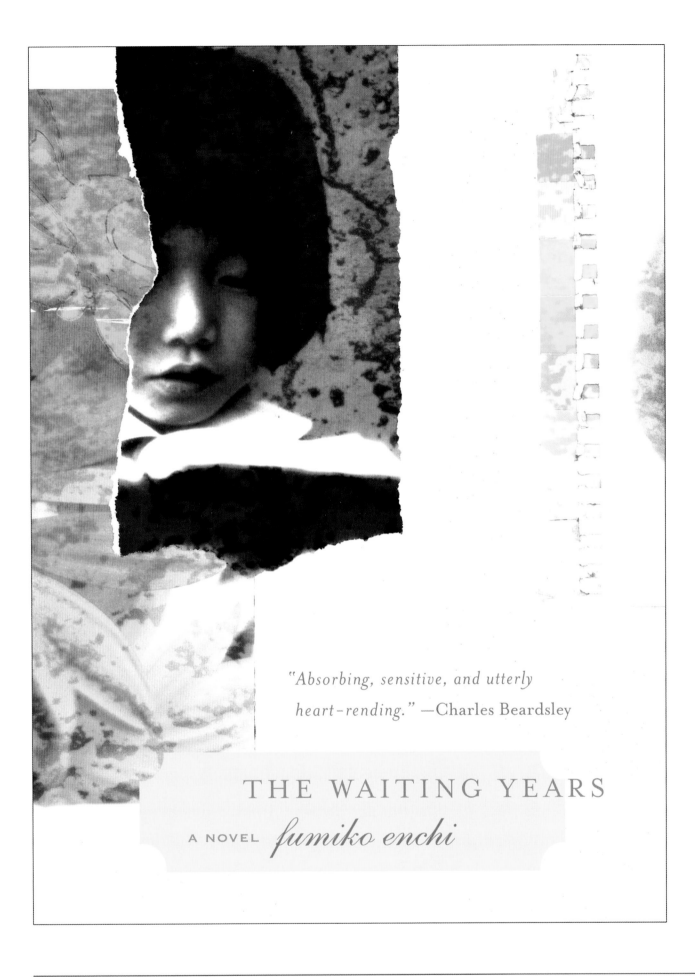

"Absorbing, sensitive, and utterly heart-rending." —Charles Beardsley

THE WAITING YEARS

A NOVEL *fumiko enchi*

"THE WAITING YEARS" Created by Joe Montgomery. Copyright © 2006.

TEXTURE:
Cement Frosting

SOURCE:
cement wall

My guess is that the guy who built this wall was not a mason.
Can anyone say "post-apocalyptic wedding cake"?

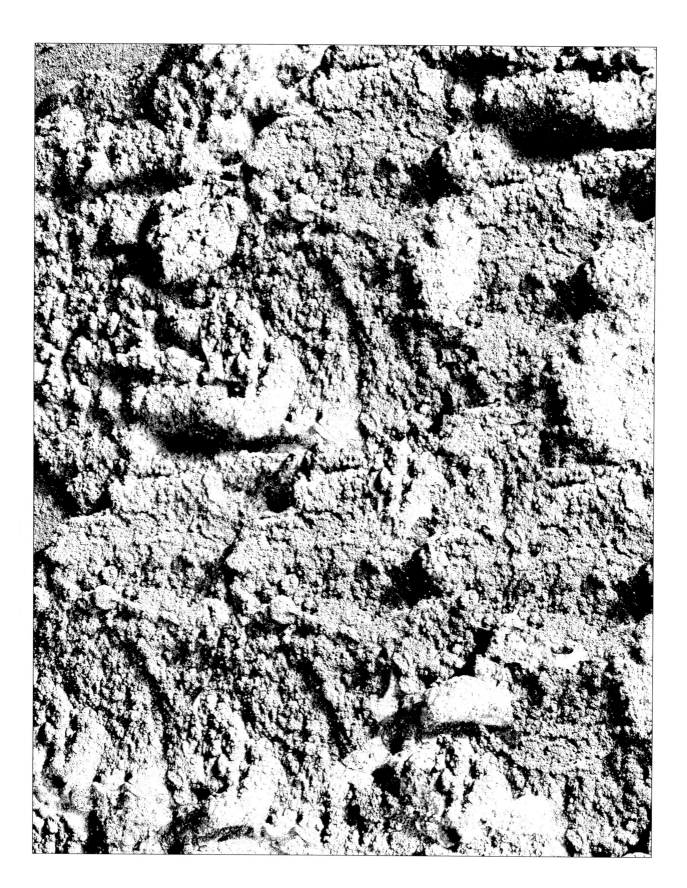

"JABBERWOCKY" Created by Dave Gink. Copyright © 2006.

TEXTURE:
Beaten Drum

SOURCE:
metal drum
or canister

This drum has been beaten to an inch of its life, and that is a very good thing. You don't have to be Ringo Starr to profit from this dilapidated canister.

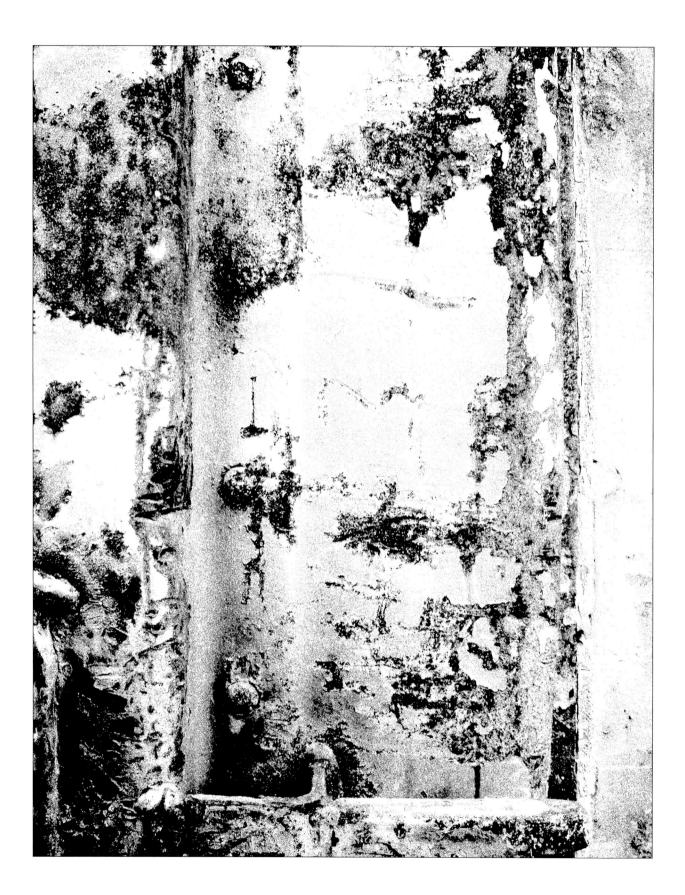

"ON THE MOVE" Created by Steve Mack. Copyright © 2006.

TEXTURE:
Sucko Stucco

SOURCE:
stucco wall

Stucco and the Pacific Northwest do not go well together… this wall proves it. You can thank the rain for decomposing this desert building material into a gorgeous mess.

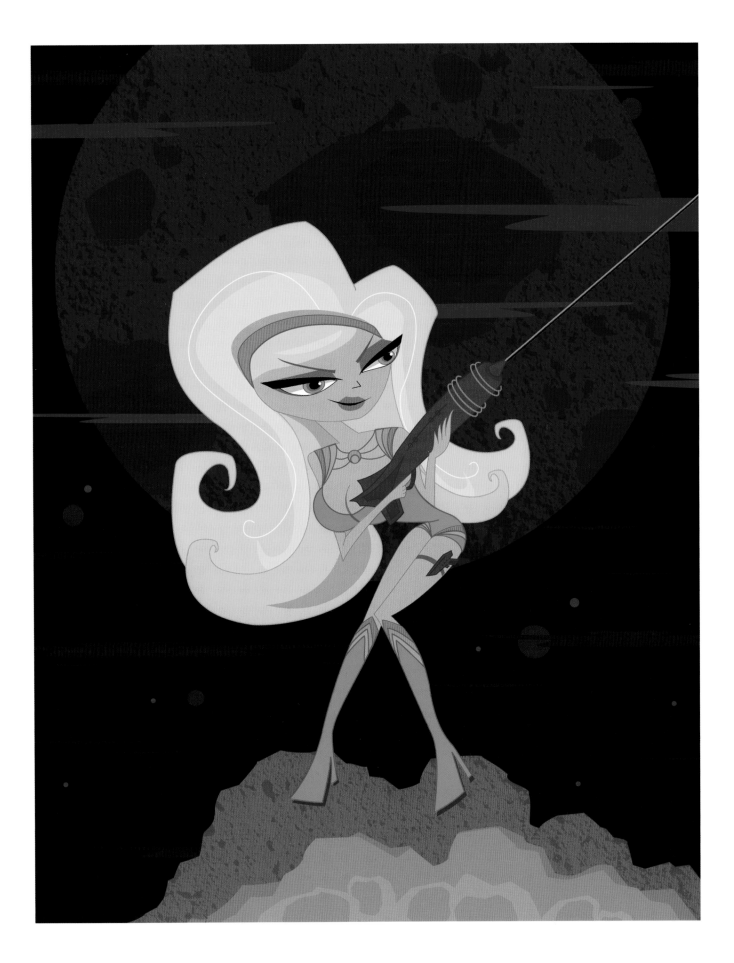

"BARBARELLA" Created by Pilar Erika Johnson. Copyright © 2006.

TEXTURE:
Trailer Trash

SOURCE:
mobile home

The not-so-proud owner of this trailer lived in a junkyard. As they say, one man's junk is another man's treasure. You don't need a plaid couch or a velvet Elvis to appreciate this fine example of deterioration. (Rusted car on blocks not included with this texture file.)

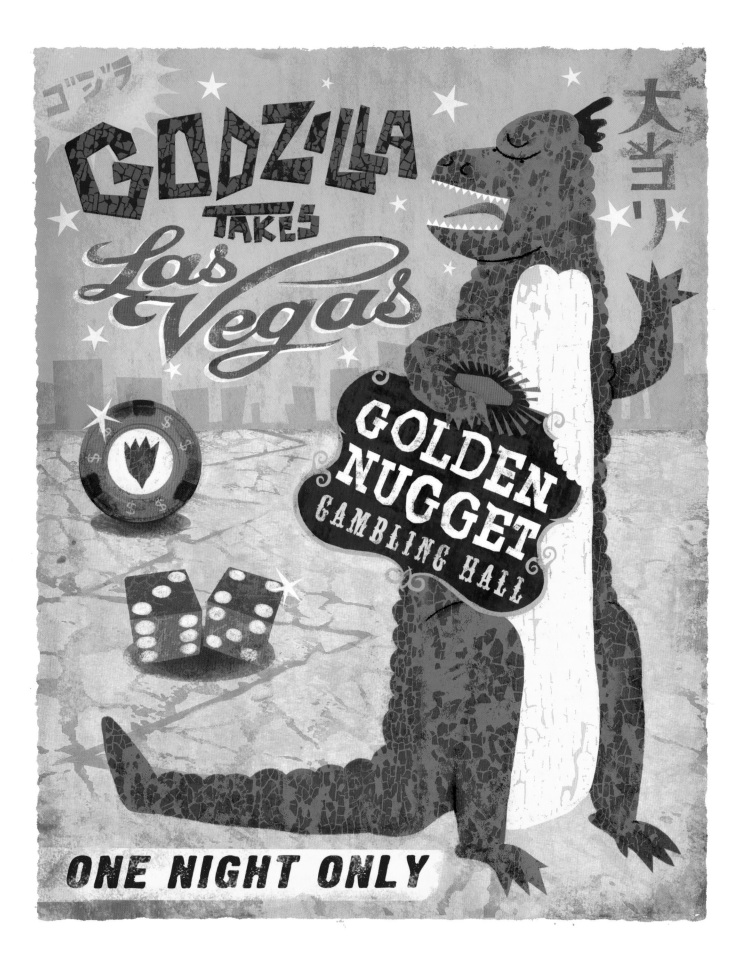

"GODZILLA TAKES LAS VEGAS" Created by Linzie Hunter. Copyright © 2006.

TEXTURE:
Junkyard Dog

SOURCE:
tractor

The only thing between me and the old abandoned tractor was a snarling dog on a chain. Thankfully, I run fast. Oh, the dangers I endure and sacrifices I make to obtain textures! (Ouch, that splinter from the last trip is still killing me.)

"FRANK N. TEAKEY" Created by Chris Parks. Copyright © 2006.

TEXTURE:
Layered
Destruction

SOURCE:
shed

If a building could get skin cancer, I would assume this one forgot
to wear sunscreen.

"AS USUAL, SUSAN HAS FORGOTTEN WHERE SHE PARKED." Created by Keith Bowman. Copyright © 2006.

TEXTURE:
Boxcar Willy 2

SOURCE:
boxcar

This vacant railroad car would even give Boxcar Willy the willies.

"THERE'S GOLD IN THEM THAR HILLS!" Created by Brian Brasher. Copyright © 2006.

TEXTURE:
Bad Mason

SOURCE:
brick wall in
an alley

All in all it's just another brick in the wall. Use this tileable texture
to build some interest in your project. (Hard hat not included.)

"GOOD INTENTIONS" Created by James Strange. Copyright © 2006.

TEXTURE:
You Crack Me Up

SOURCE:
painted
metal canister

Time, weather and wear collaborated on this postmodern industrial canvas. Inferior prep work and bad painting never looked so good.

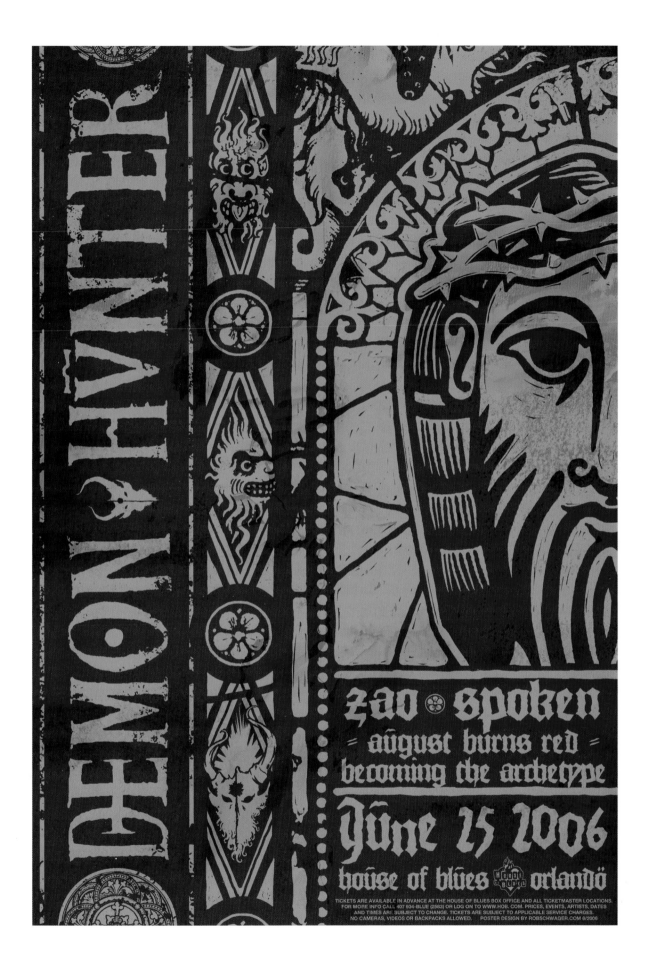

"DEMON HUNTER" Created by Rob Schwager. Copyright © 2006.

TEXTURE:
Shipwreck

SOURCE:
wood deck

Neglected over time, this landlocked vessel steered its own course through the ocean of decay. Smart captains of design recognize the aesthetic value of rot.

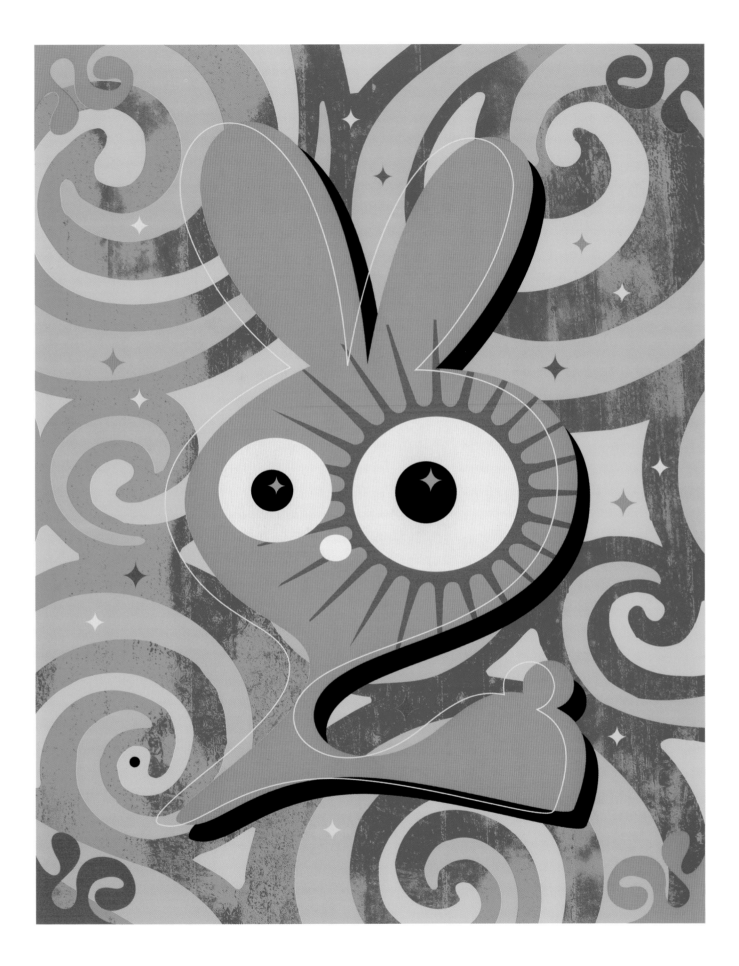

"MAGIC BUNNY" Created by Molly Zakrajsek. Copyright © 2006.

TEXTURE:
Pit Stains

SOURCE:
tanker car

Life for a painted metal surface can be the pits, literally. Acid rain has its benefits, I suppose.

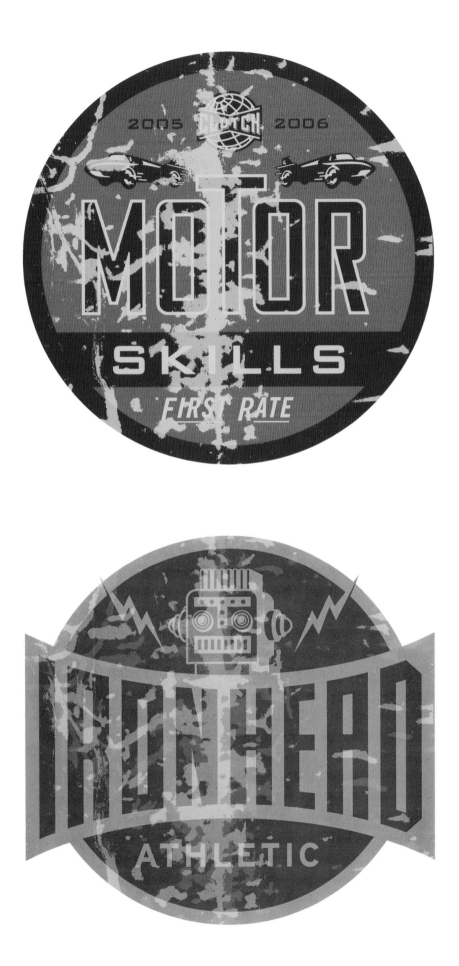

"MOTOR SKILLS AND IRONHEAD" Created by Tim Frame. Copyright © 2006.

TEXTURE:
Chipped Scab

SOURCE:
painted metal

My mom always told me not to pick at my scabs. See what happens when you don't listen to your mom? (You end up in a texture book!)

"GOTHIC" Created by Ben Lane. Copyright © 2006.

TEXTURE:
Alien Dermis

SOURCE:
stone slab

Have you ever seen alien skin? Nether have I, but I thought it might look something like this. No, there weren't any flashing green lights or orbs nearby when I took this shot.

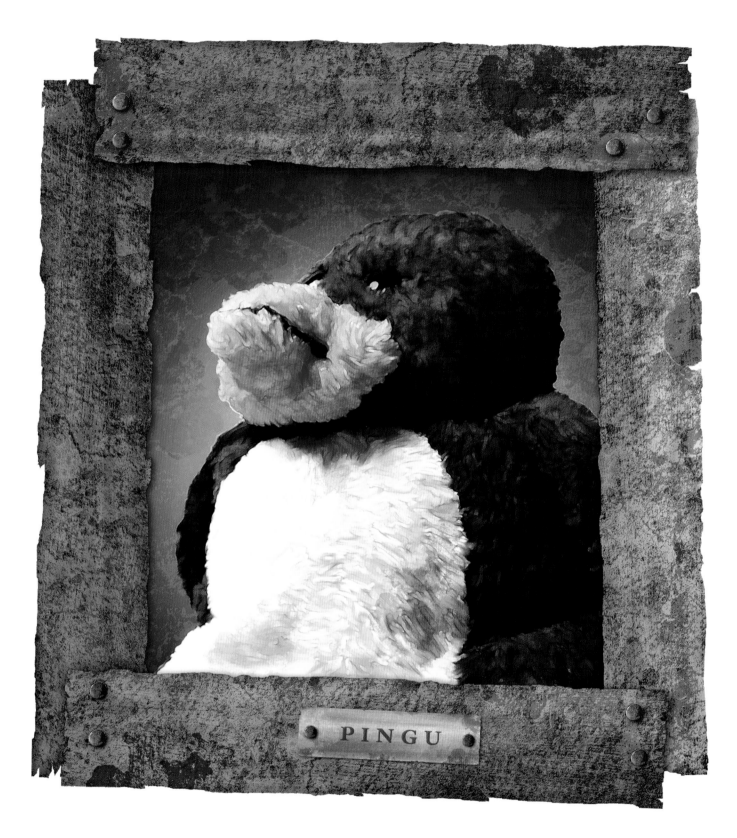

PINGU

"PINGU" Created by Jeope Wolfe. Copyright © 2006.

TEXTURE:
Sinful Planks

SOURCE:
old church

If cleanliness is next to godliness, then this church should repent for its apostate exterior.

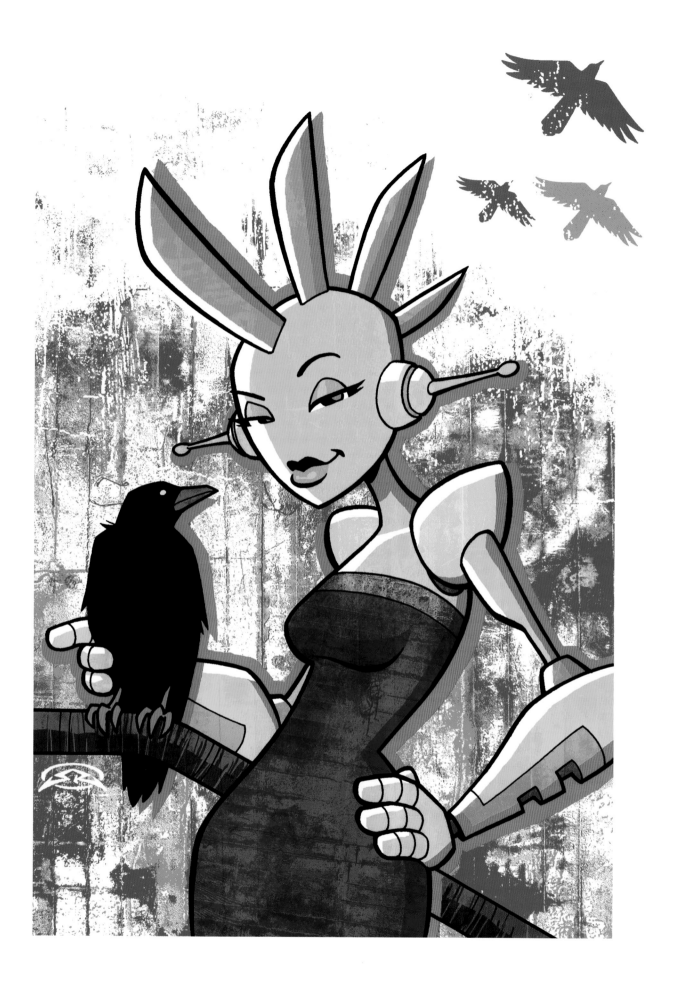

"CHILI PLUS CROW" Created by Steve Rolston. Copyright © 2006.

TEXTURE:
Inner City Strata

SOURCE:
downtown alley

No fossils here, but lots of rocky goodness. Think of it as a geological lasagna to add to your design menu.

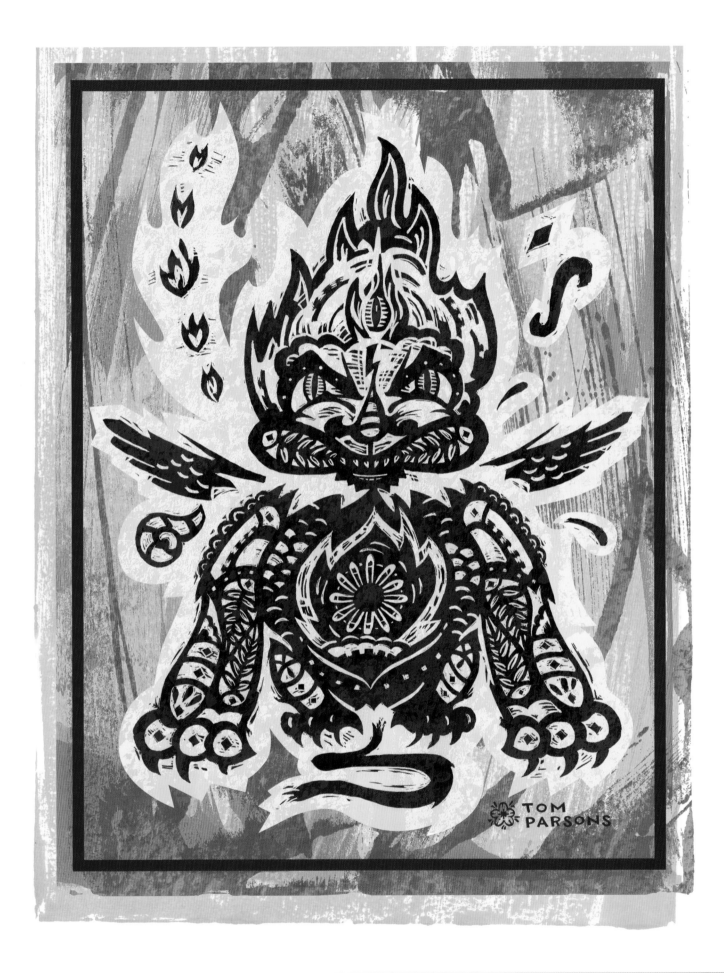

"SUSAN THE BLACK-EYED DRAGON" Created by Tom Parsons. Copyright © 2006.

TEXTURE:
Shards of Decline

SOURCE:
old industrial
warehouse

Go against the grain with this crappy veneer.

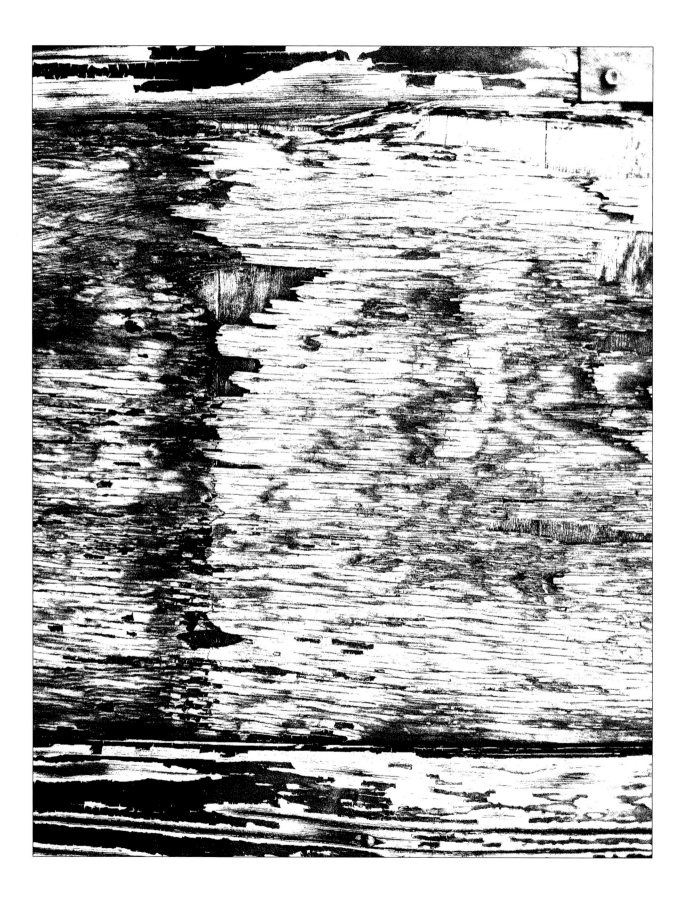

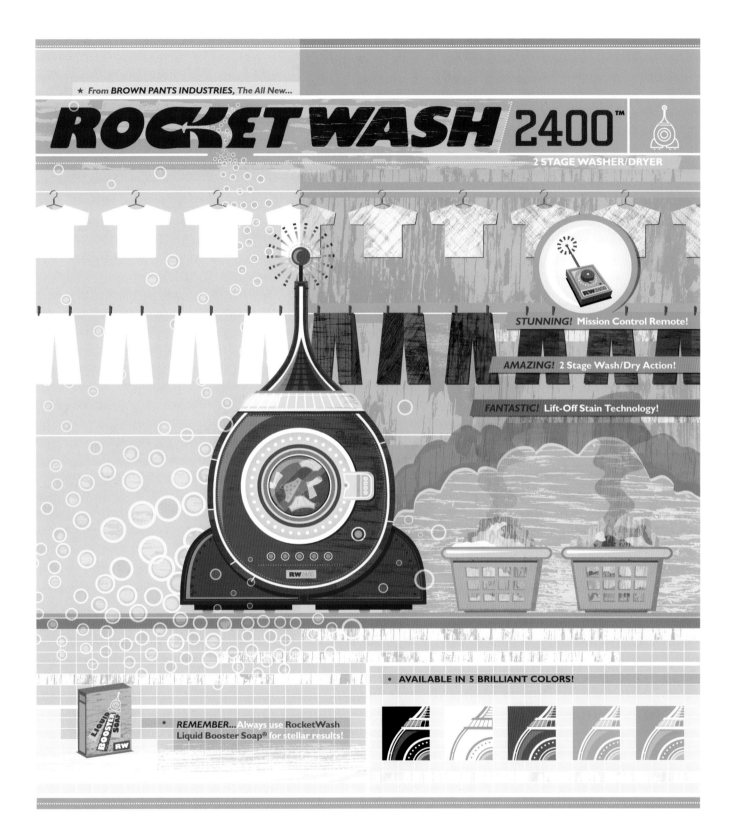

"ROCKET WASH 2400" Created by Ben Schlitter. Copyright © 2006.

TEXTURE:
Urban Decay

SOURCE:
parking garage wall

"Look Martha, a funny man is taking photos of the parking garage."
"Oh George, do lock the doors and roll up your window. That kind of riff-raff loves to beg for money." Sigh. What strange looks we put up with when we are out texture exploring.

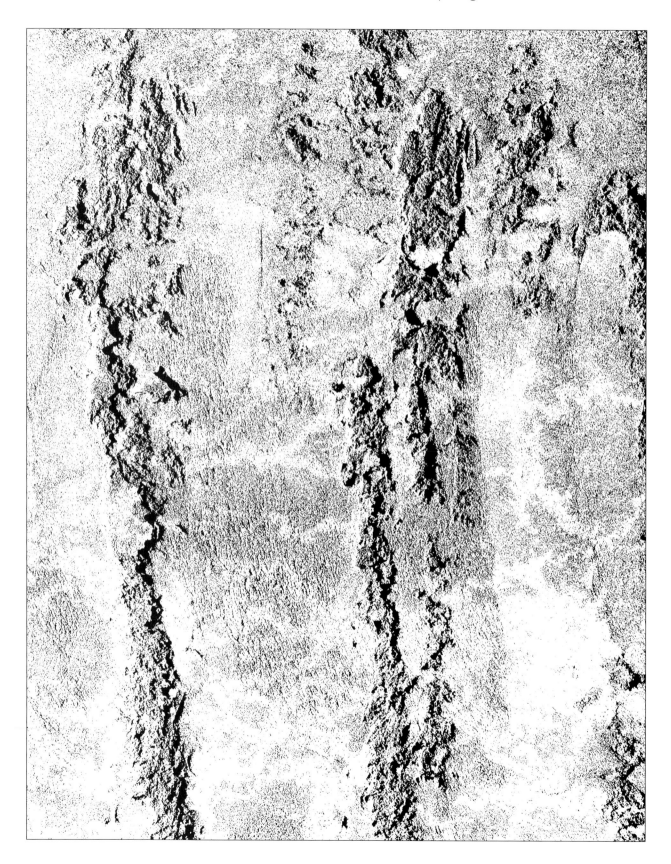

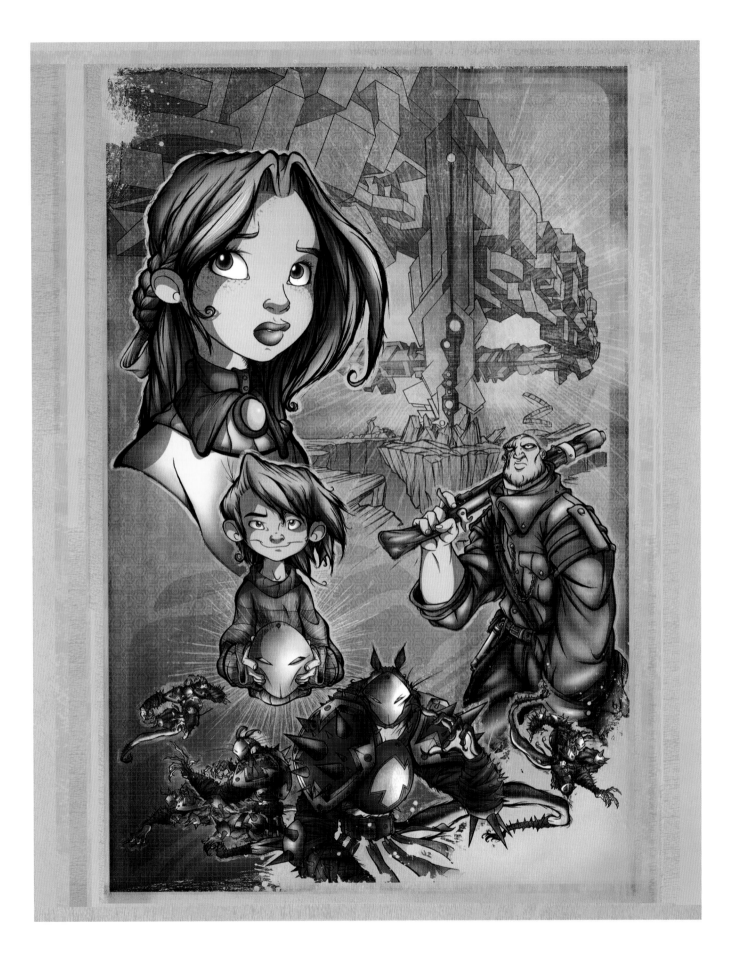

"MOSAIC" Created by Robert Duenas and Adam Cogan. Copyright © 2006.

TEXTURE:
Crumbled Wall

SOURCE:
apartment complex
basement

Apple crumble, rhubarb crumble... wall crumble? This tasty image
will satisfy your hunger for creativity and appetite for gritty textures.

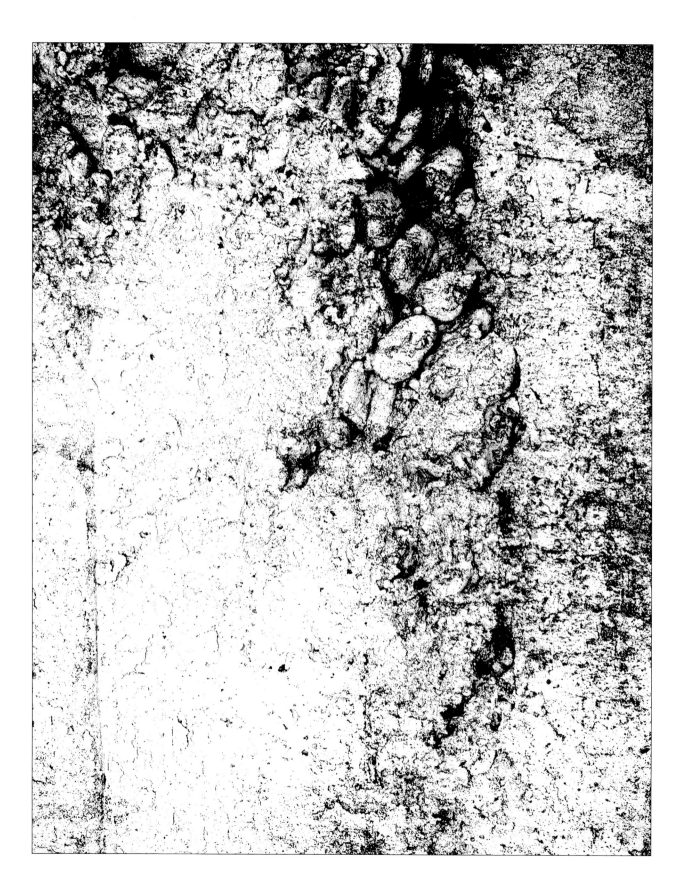

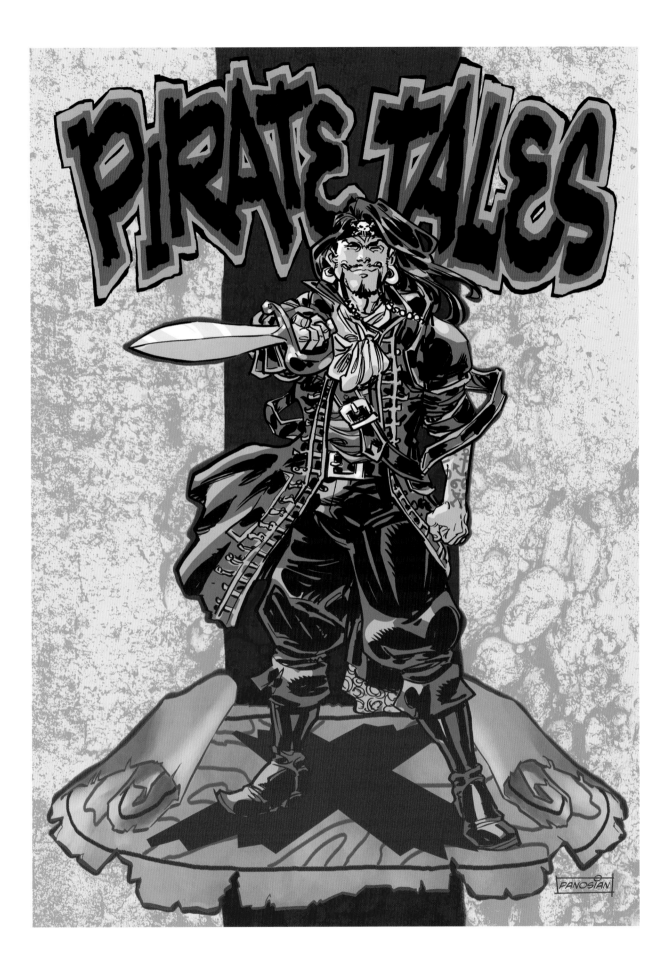

"PIRATE TALES" Created by Dan Panosian. Copyright © 2006.

TEXTURE:
Metro Degradation

SOURCE:
hole in wall

A committee was formed to decide how to repair a hole in a concrete wall. After much deliberation, they decided to use wood. Duh!

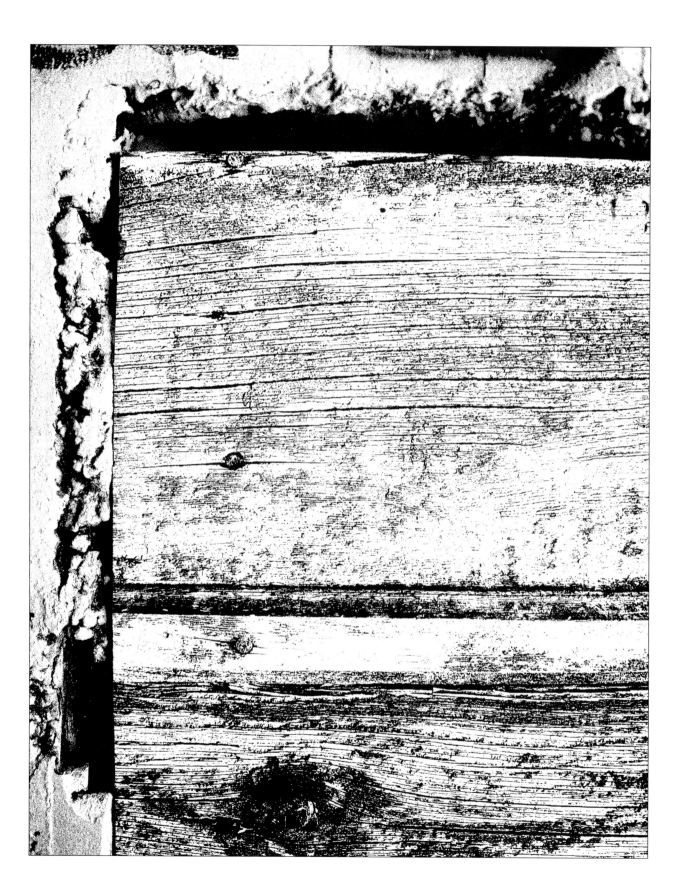

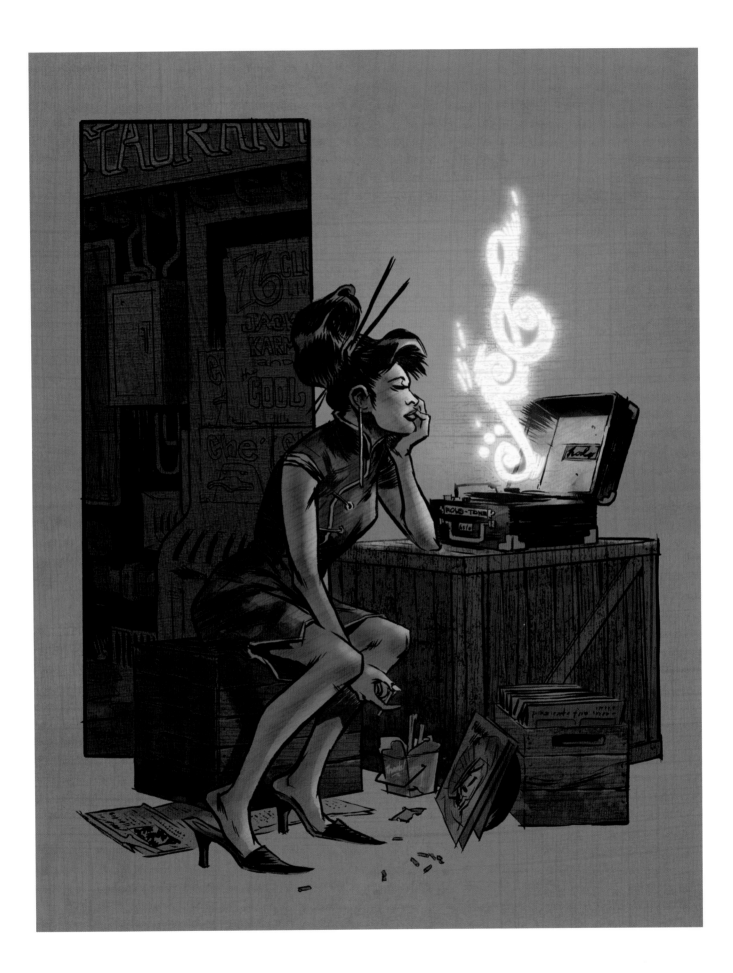

"AFTER HOURS" Created by Ed Tadem. Copyright © 2006.

TEXTURE:
Social Breakdown

SOURCE:
downtown alley

This dark alley was very creepy, but well worth the find. Between dumpsters and boarded-up doorways—surrounded by putrid odors, stained walls and scattered refuse—live some of the best textures.

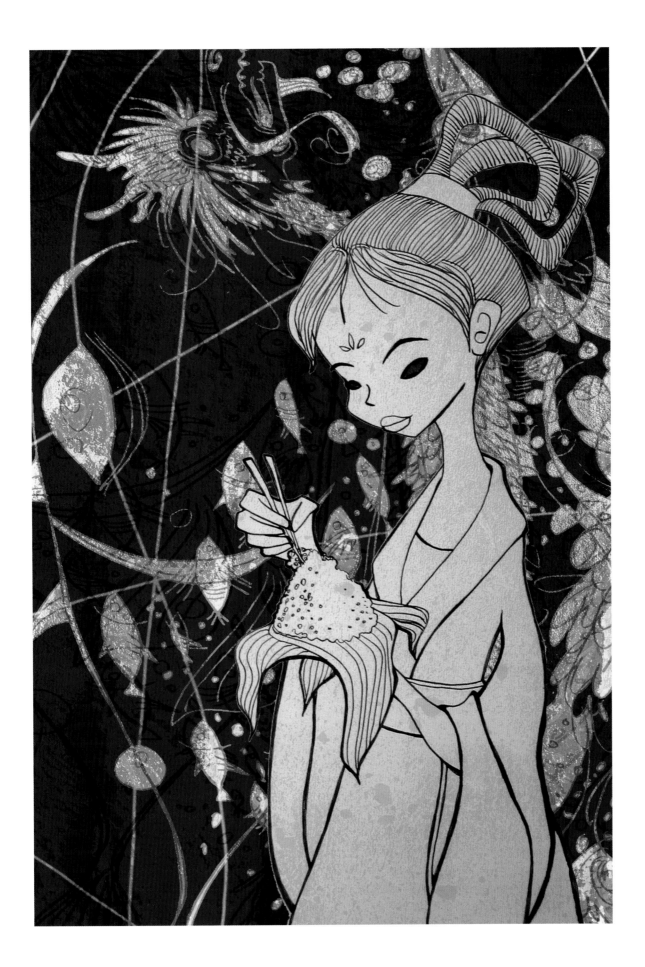

"CHINESE DRAGON BOAT FESTIVAL" Created by Alina Hiu-Fan Chau. Copyright © 2006.

TEXTURE:
Private Decomp

SOURCE:
sign outside
old building

The security car rolled by slowly. The PA blared, "Please do not take pictures of the building." Of course I snapped a few... and then ran like a gazelle. Watch out for the long arm of the law—they're not always in tune with the higher ideals of texture exploring.

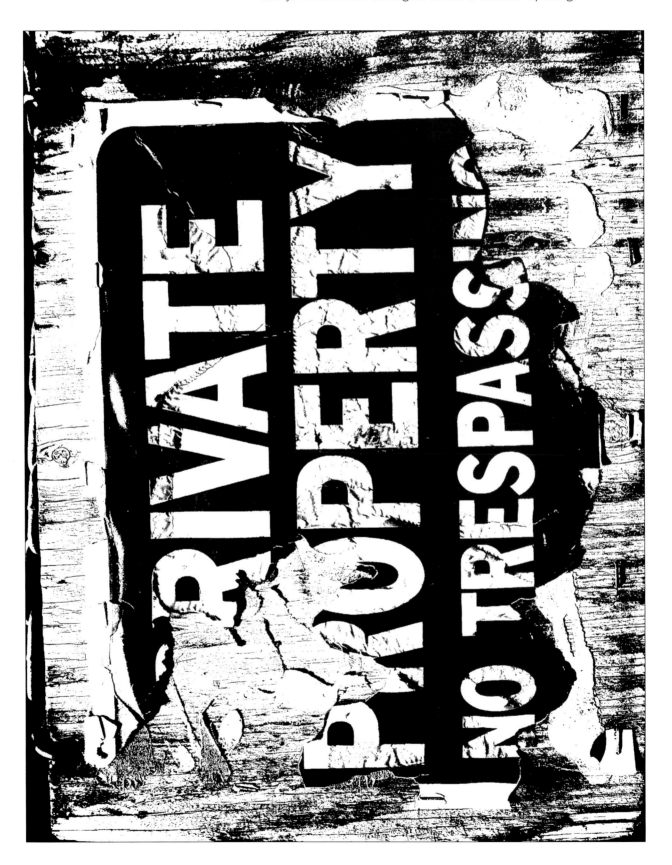

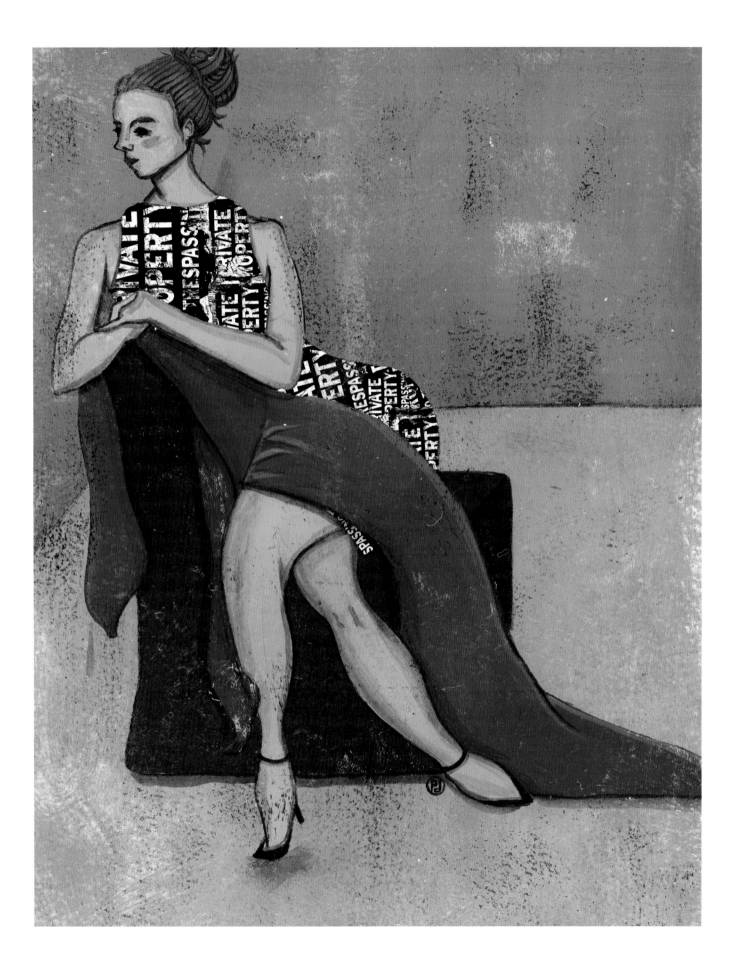

"RED TAPE" Created by Penelope Dullaghan. Copyright © 2006.

TEXTURE:
Retaining Entropy

SOURCE:
retaining wall

Ironically enough, this retaining wall does not retain anything. But I guarantee that its intricately oxidized edges will retain the interest of those who view your art.

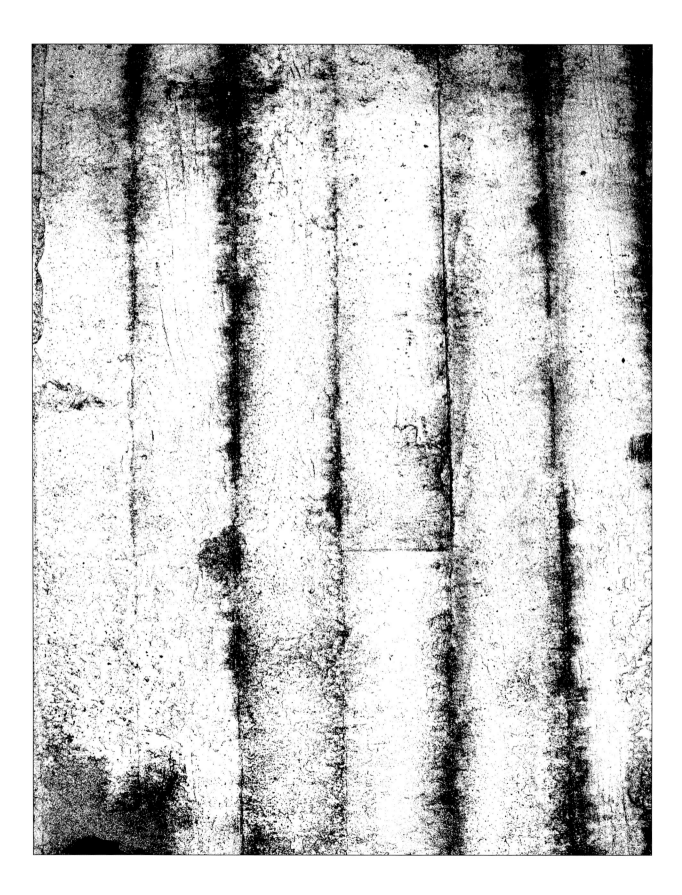

"WILLIAM H. MACY CARICATURE" Created by Kody Chamberlain. Copyright © 2006.

TEXTURE:
Crack Horror

SOURCE:
T-shirt

Over time, the aging plastisol ink used on my T-shirt had begun to crack. Very cool. I look down at my gut, and see the Mohave Desert!

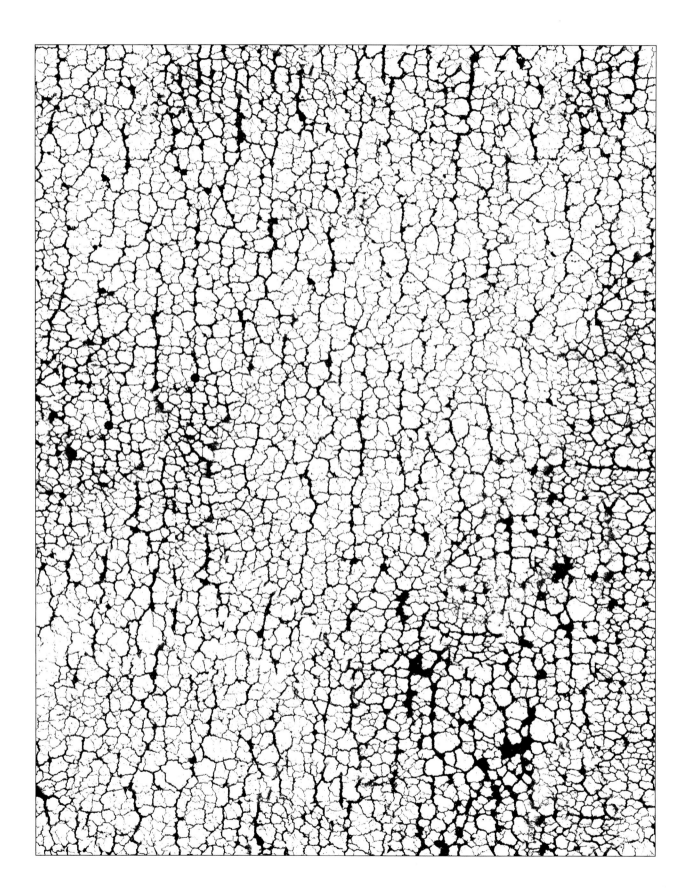

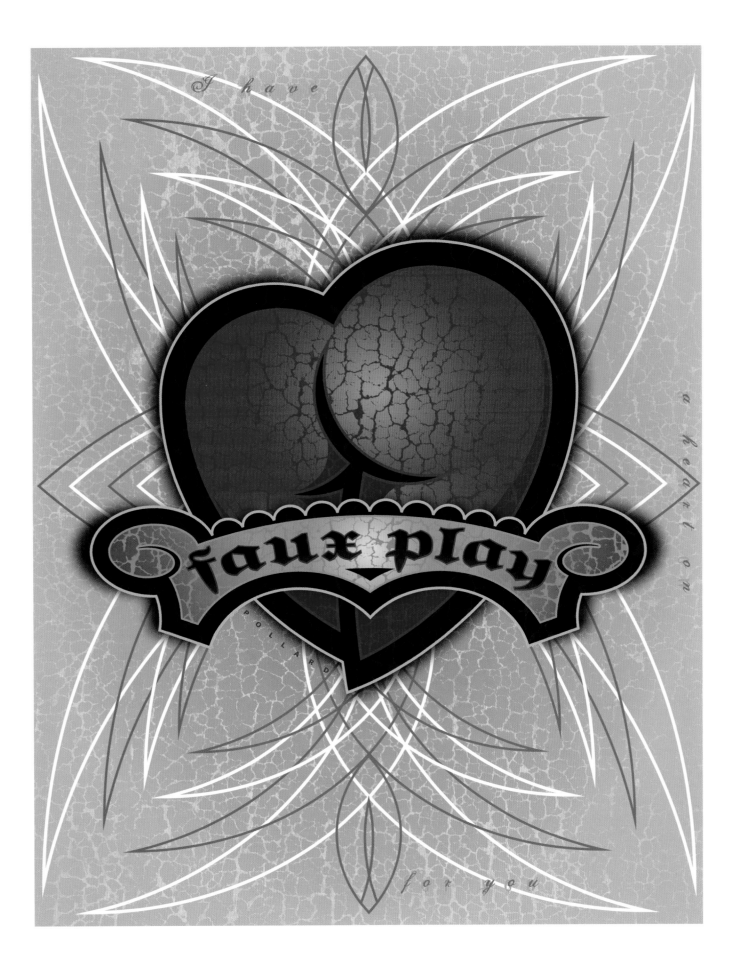

"FAUX PLAY" Created by Jeff Pollard. Copyright © 2006.

TEXTURE:
Industrial
Scar Tissue

SOURCE:
waste canister

Neglected and forgotten, this mud-caked container reveals how the ravages of time can create a splendid ruin. Don't waste the opportunity to use this in your art.

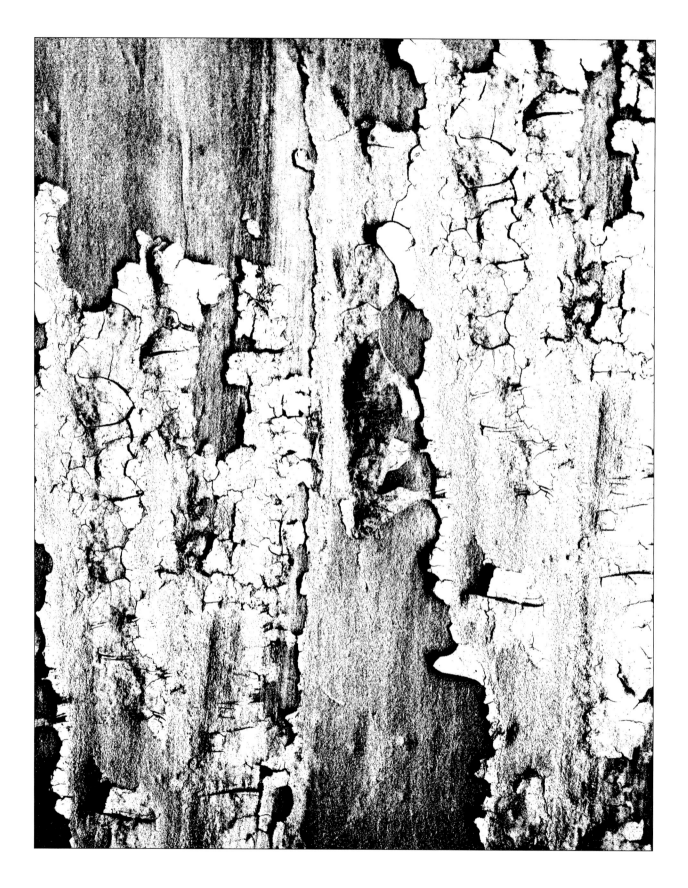

"TEMPORAL INFESTATION" Created by Von R. Glitschka. Copyright © 2006.

TEXTURE:
Crumbled

SOURCE:
wood tabletop

Candlelight, fine linen and silverware will grace this tabletop never-more. But its unique surface markings remain a feast for the eyes.

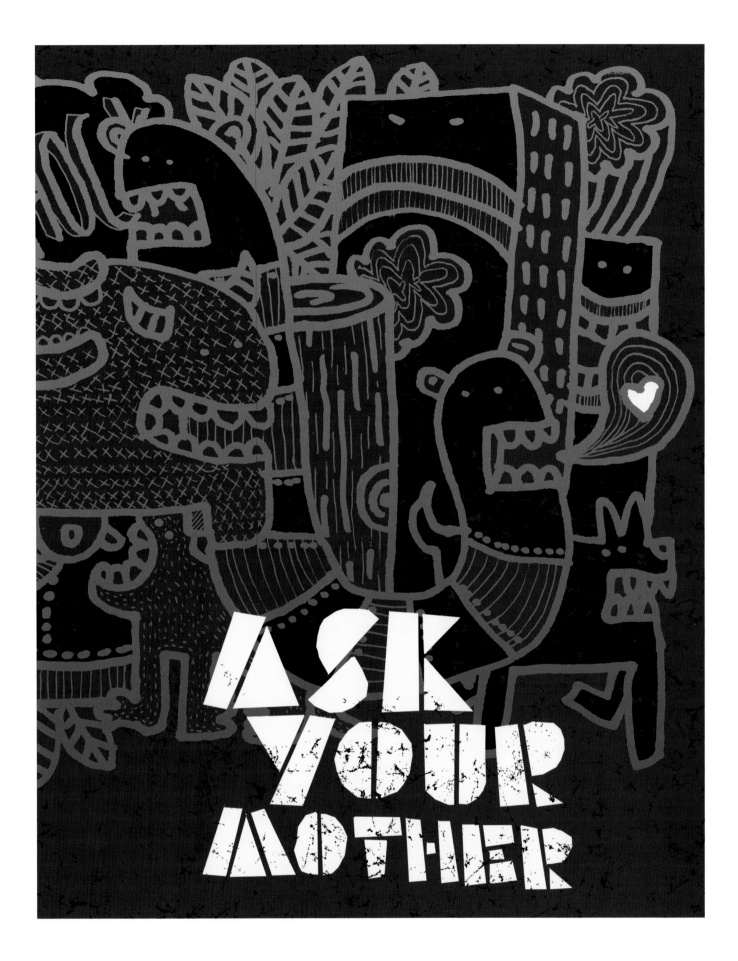

"ASK YOUR MOTHER" Created by MAKI. Copyright © 2006.

TEXTURE:
Skid Marks

SOURCE:
old copy machine

Keep the service guy away! Low toner, a scratched drum and worn gears all produce wonderful artifacts on my copies.

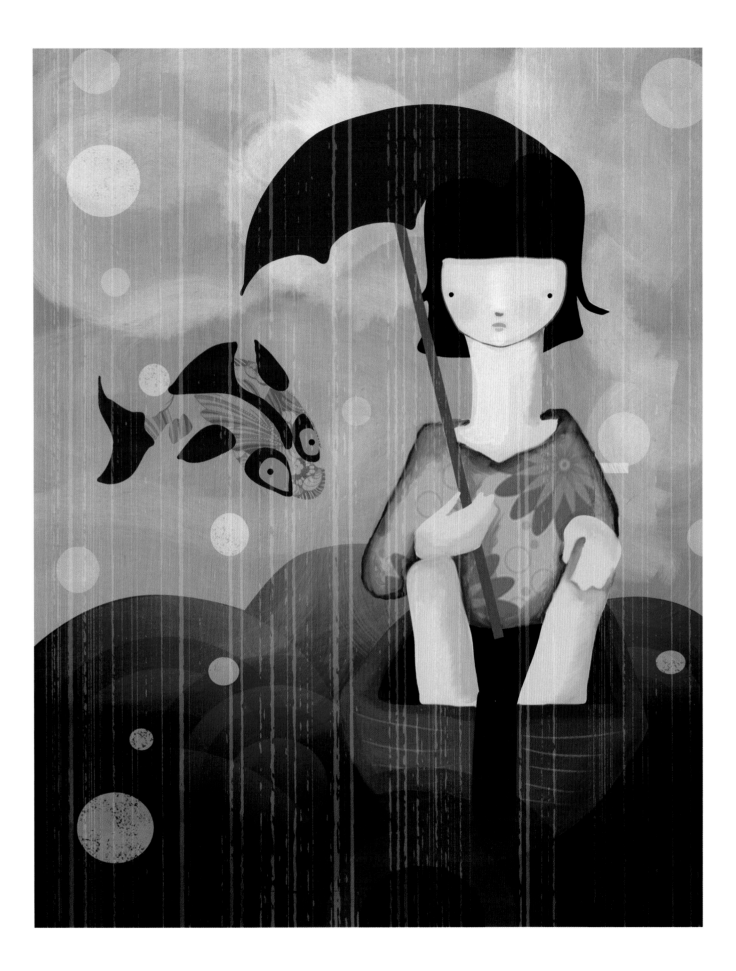

"ADRIFT" Created by Annie Wilkinson. Copyright © 2006.

TEXTURE: **SOURCE:**
Ancient Manuscript old parchment

This well-read and cherished tome shows the hallmarks of scholarly appreciation and study. Its timeworn luster will enrich your projects, whether you're using uncials or Univers.

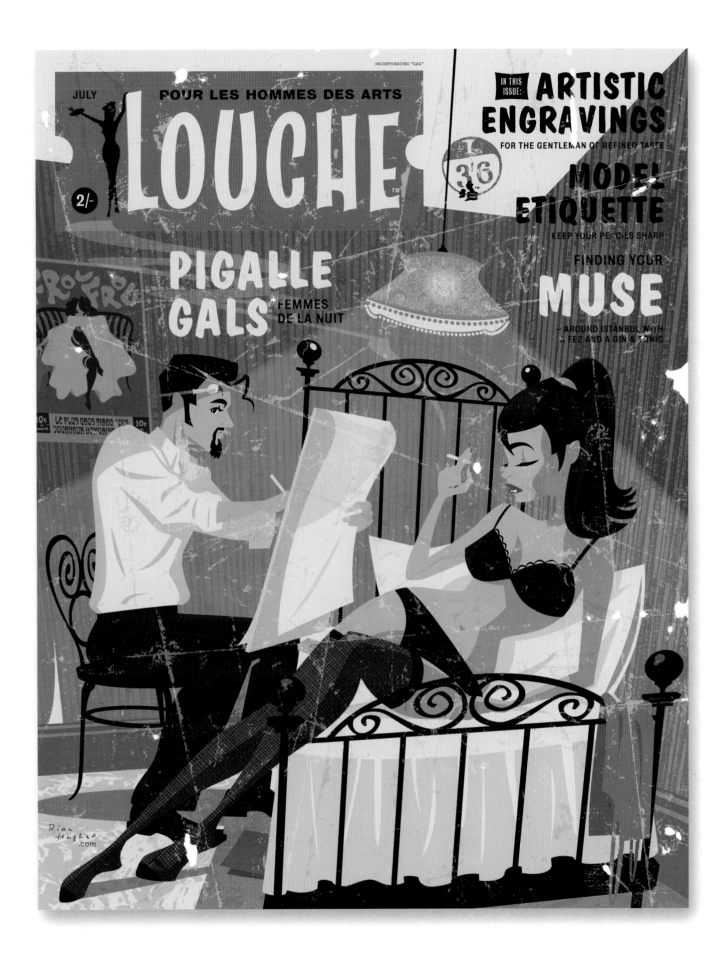

"POUR LES HOMME DES ARTS" Created by Rian Hughes. Copyright © 2006.

TEXTURE:
Thrashed Door

SOURCE:
fire department
training building

The interior of this "burn house" was painted black and stained with soot. Over time the paint wore away due to heavy use and abrasion.

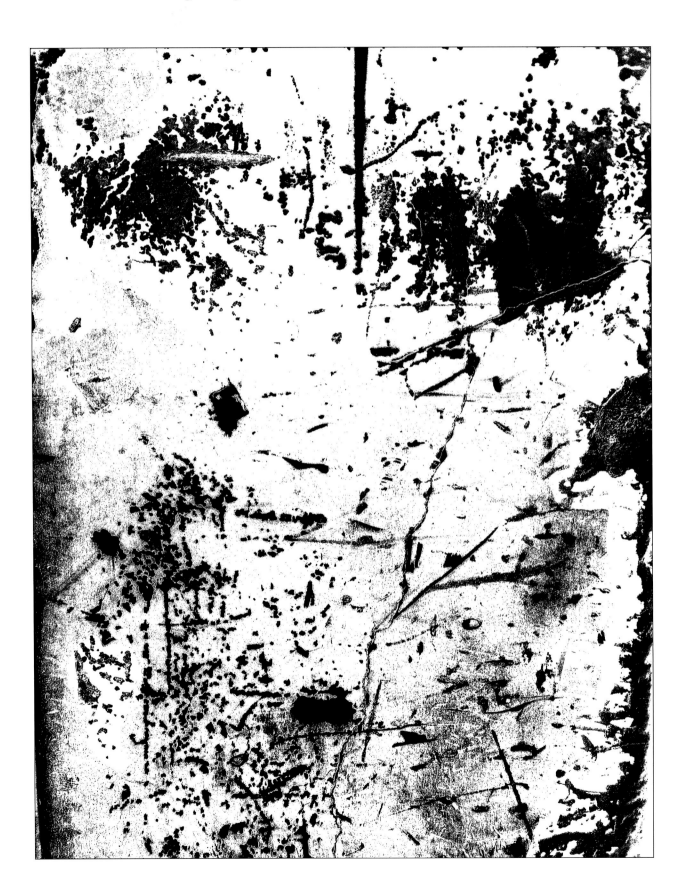

"FIGURE PAINTING" Created by Greg Epkes. Copyright © 2006.

TEXTURE:
Mohave Cracks

SOURCE:
Mohave Desert

In hot desert conditions, this pavement crumpled to pieces. In the comfort of your air-conditioned office, you can create your own masterpieces.

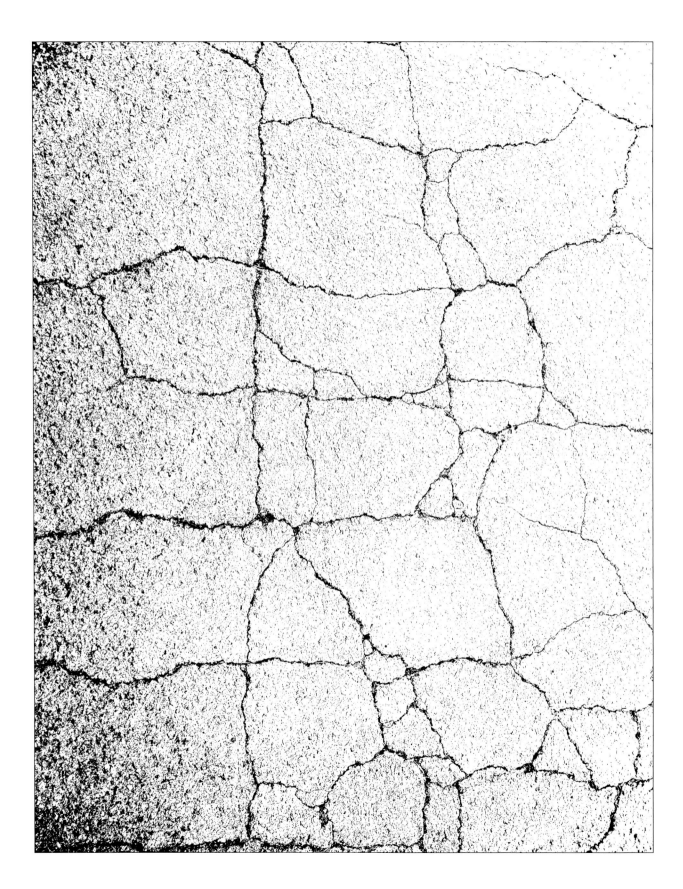

"NO PLACE TO CHANGE" Created by Nathan Santistevan. Copyright © 2006.

TEXTURE:
Wall of Shame

SOURCE:
railroad
retaining wall

Even the Little Engine That Could couldn't restore this damaged
railway wall to its original condition. But you'll be right on track if
you use its texture in your art.

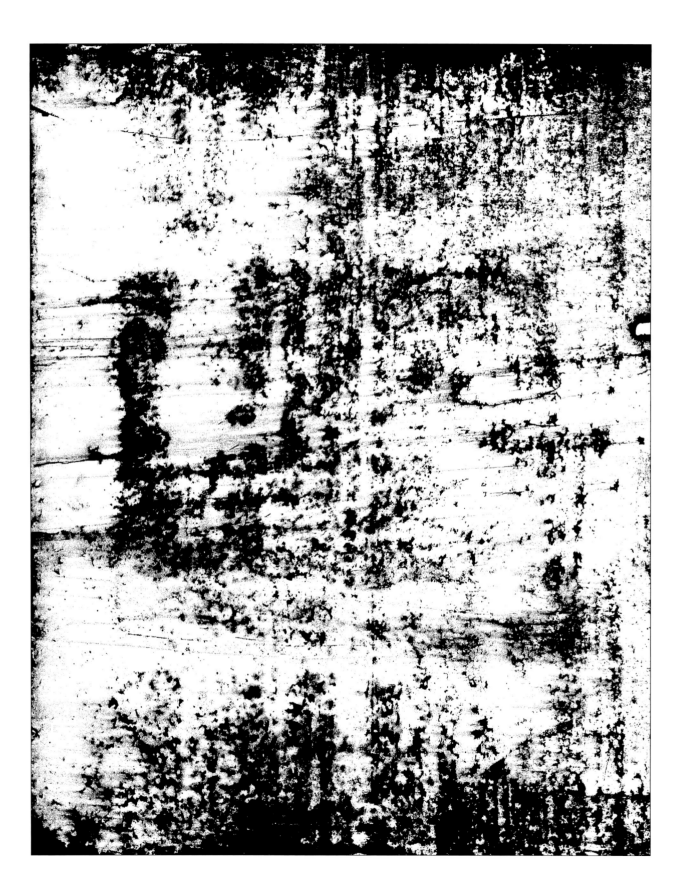

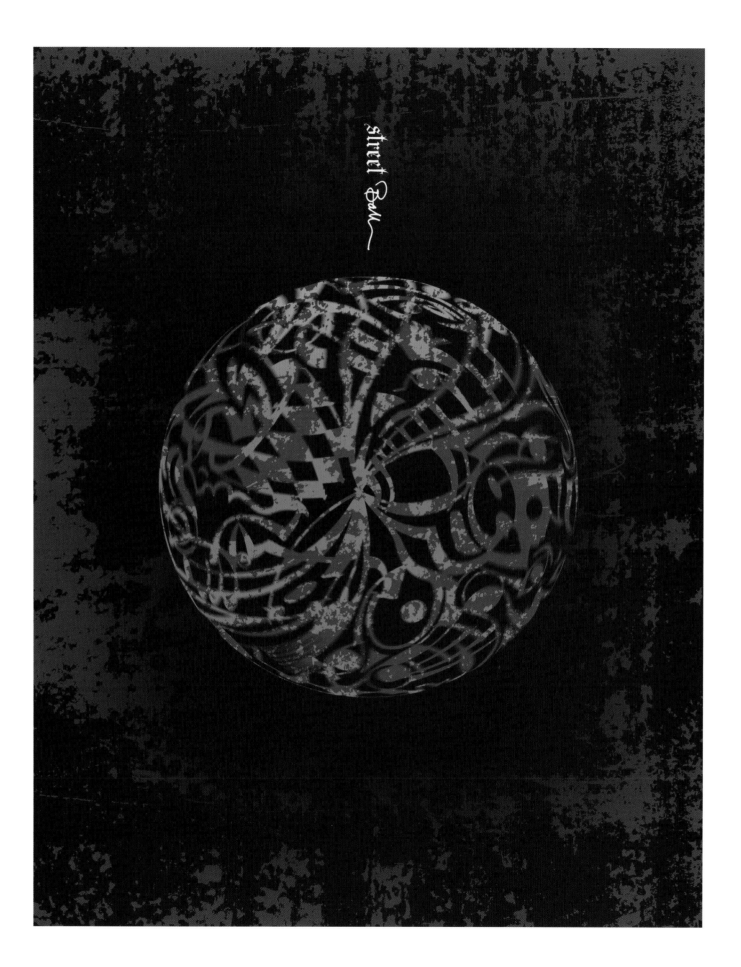

"STREET BALL" Created by Ryan Kaps. Copyright © 2006.

TEXTURE:
Mud Splatter

SOURCE:
junkyard crane

Don't even think of bringing a pressure washer near this machine.
Years of mud, filth and grime have made it sublime.

78

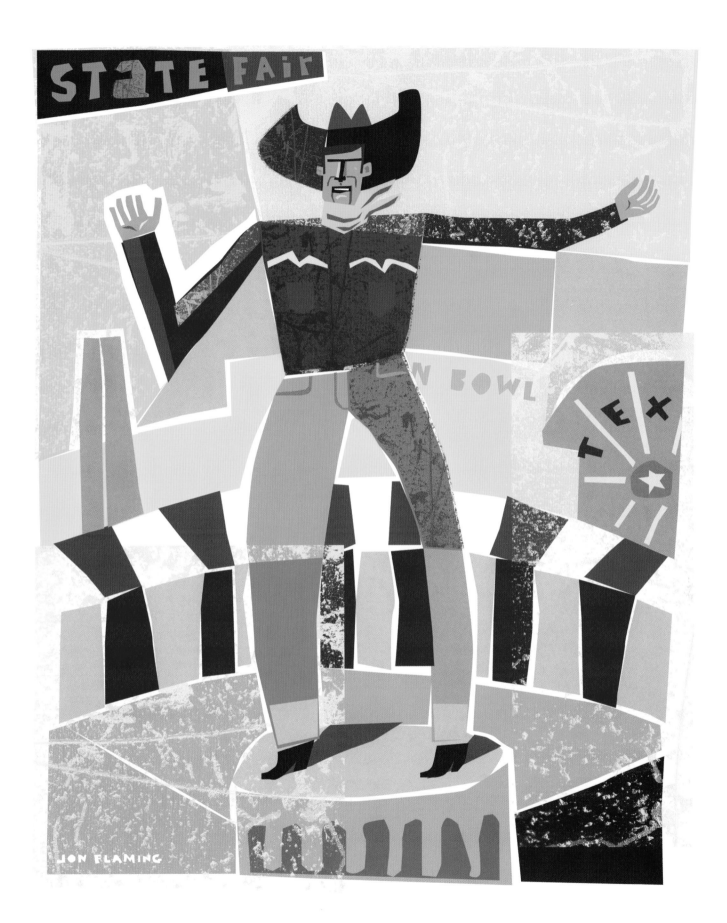

"BIG TEX" Created by Jon Flaming. Copyright © 2006.

TEXTURE:
Festering Floor

SOURCE:
Glitschka
family garage

Sometimes you don't have to go far to find cool textures. Our new home has a perfectly distressed garage floor.

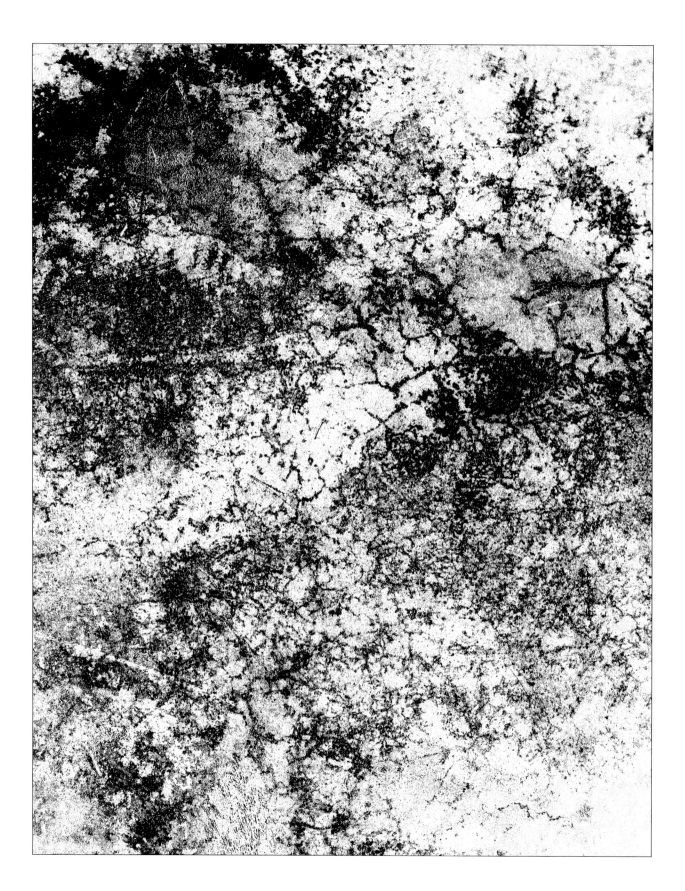

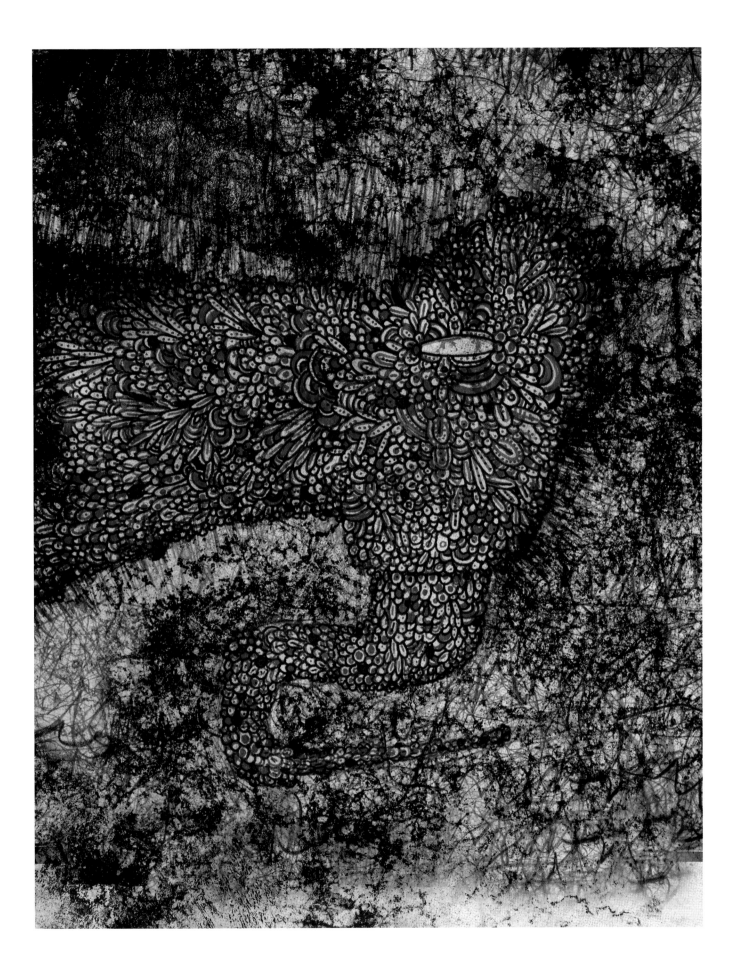

"HAROLD" Created by THINKMULE. Copyright © 2006.

TEXTURE:
Great Scrape

SOURCE:
earth mover

When you move tons of dirt every day, you're bound to get a few cool-looking scrapes on your body.

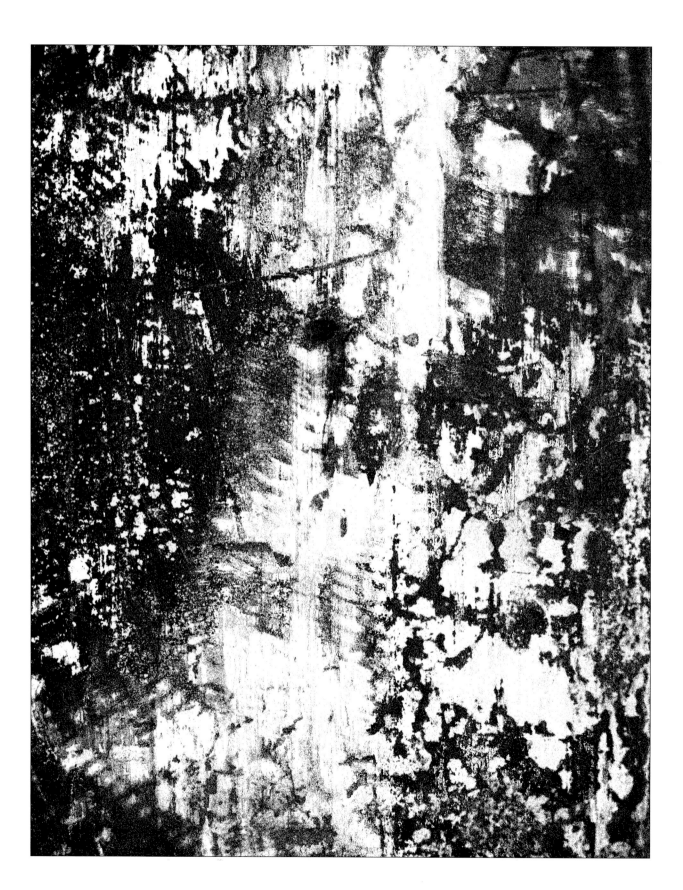

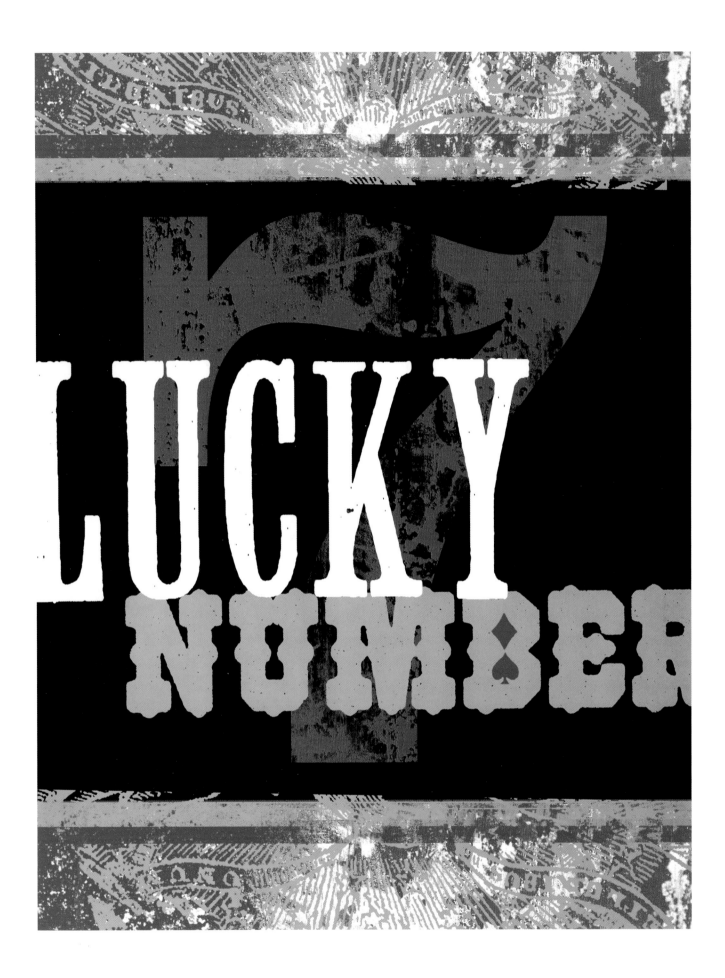

"LUCKY NUMBER SEVEN" Created by Andy Hayes. Copyright © 2006.

TEXTURE:
Edifice of Erosion

SOURCE:
warehouse
foundation

Erosion takes time. But all good things come to those who wait.

"HOO DO YOU LOVE" Created by Von R. Glitschka. Copyright © 2006.

TEXTURE:
Crackle

SOURCE:
Arizona Desert

Mother Nature and Father Time had a fling...their love child is this gorgeous design element.

"TRIBAL FLAIR" Created by Von R. Glitschka. Copyright © 2006.

TEXTURE:
Curb Appeal

SOURCE:
parking lot

Park this texture on your design, and benefit from its well-worn appeal. It's sure to be the driving force behind a great new concept.

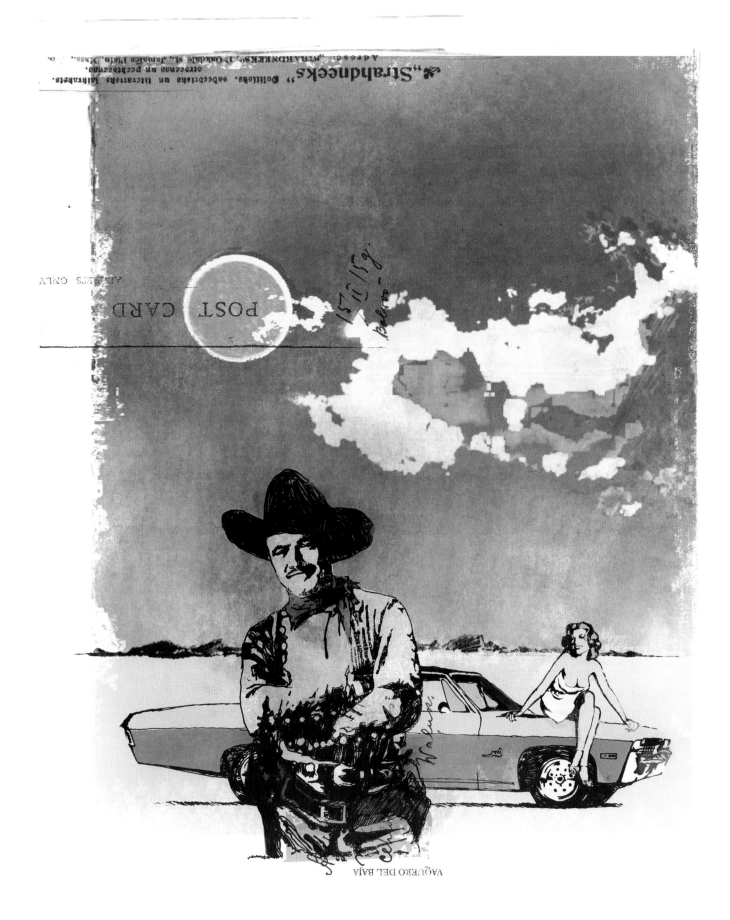

"RUMOROSA RUN" Created by Ben Mallory. Copyright © 2006.

TEXTURE:
Building Scab

SOURCE:
parking garage

Like a mole on a supermodel's face, this singular and wonderfully obnoxious surface contrasted with the facility's otherwise smooth pavement and pillars.

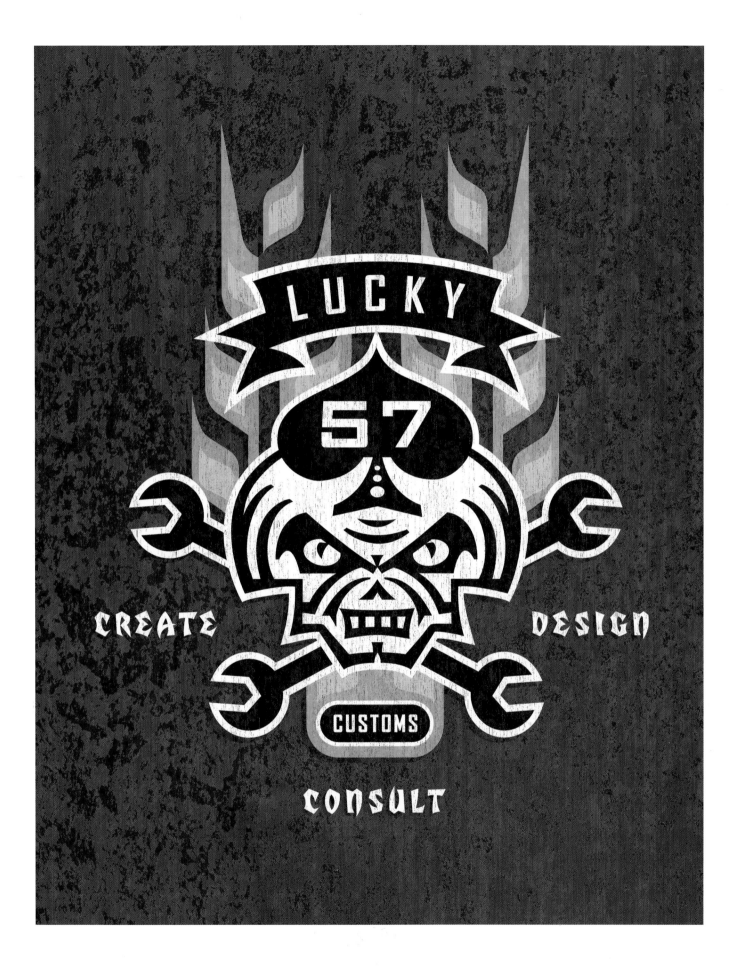

"LUCKY 57" Created by Paul Howalt. Copyright © 2006.

TEXTURE:
Ugly Aggregate

SOURCE:
walking path

A passerby asked, "Why are you taking a picture of the ground?" I responded, "It looks cool." Not saying anything, he stared at me, then at the ground, then back at me, and finally walked away.

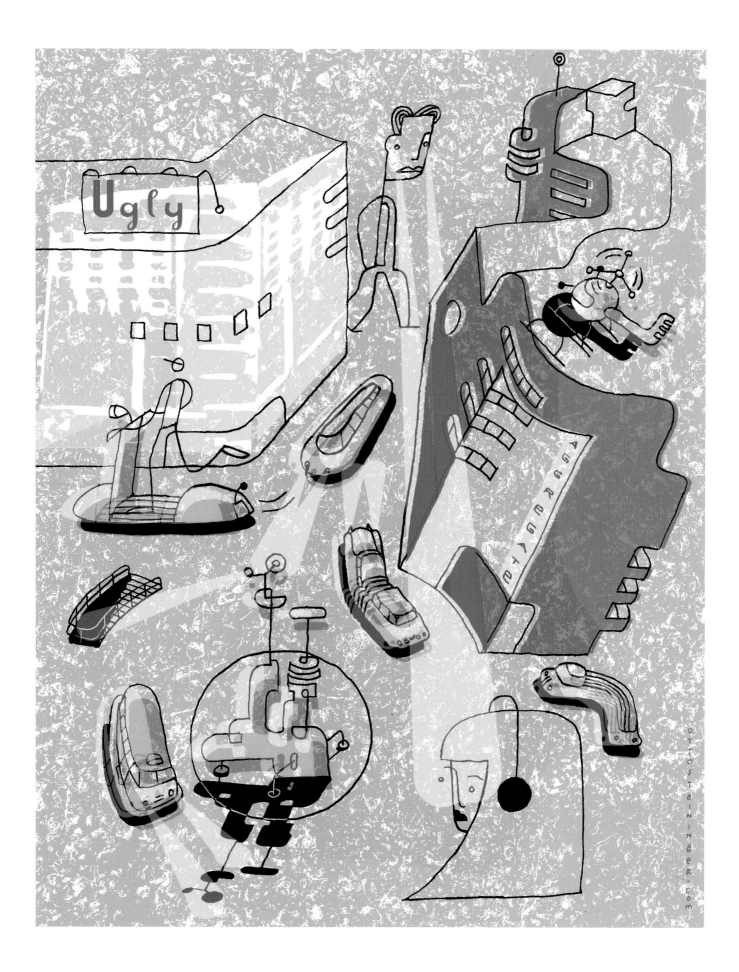

"LOOK AT ME" Created by Otto Steininger. Copyright © 2006.

TEXTURE:
Volatile Veneer

SOURCE:
tool shed

For years, the intense desert sun roasted this plywood sheet, creating a perfectly broiled and distressed texture.

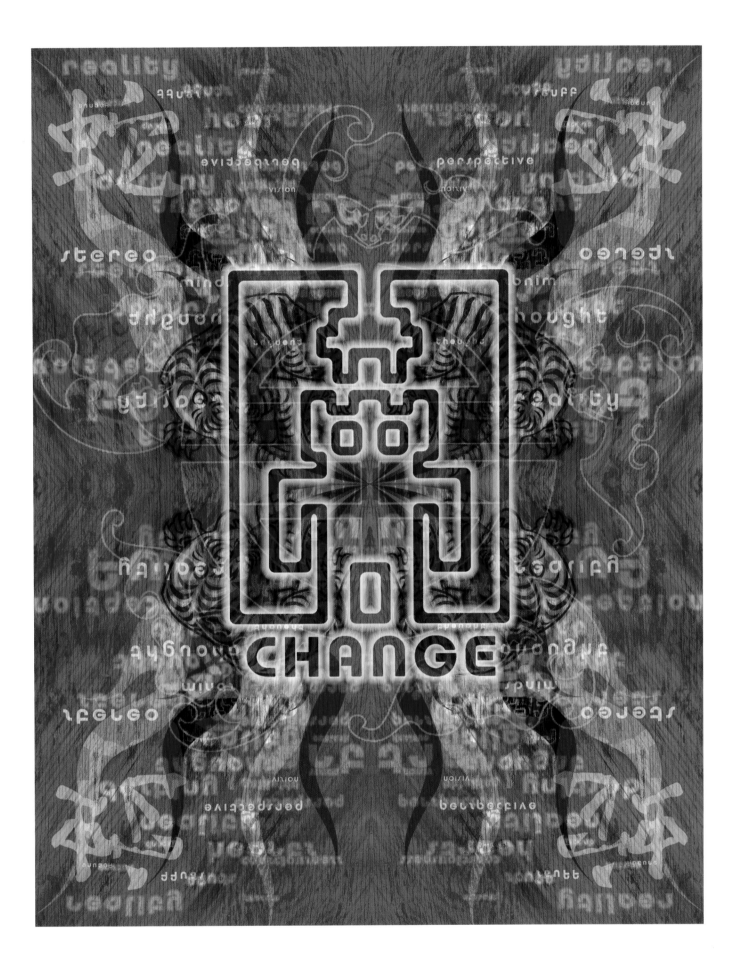

"**CHANGE**" Created by David Lomeli. Copyright © 2006.

TEXTURE:
Destroyed
Dumpster

SOURCE:
junkyard dumpster

Is there a dumpster to put old dumpsters in? A dumpster in a junkyard seems kind of redundantly ironic, not to mention ironically redundant.

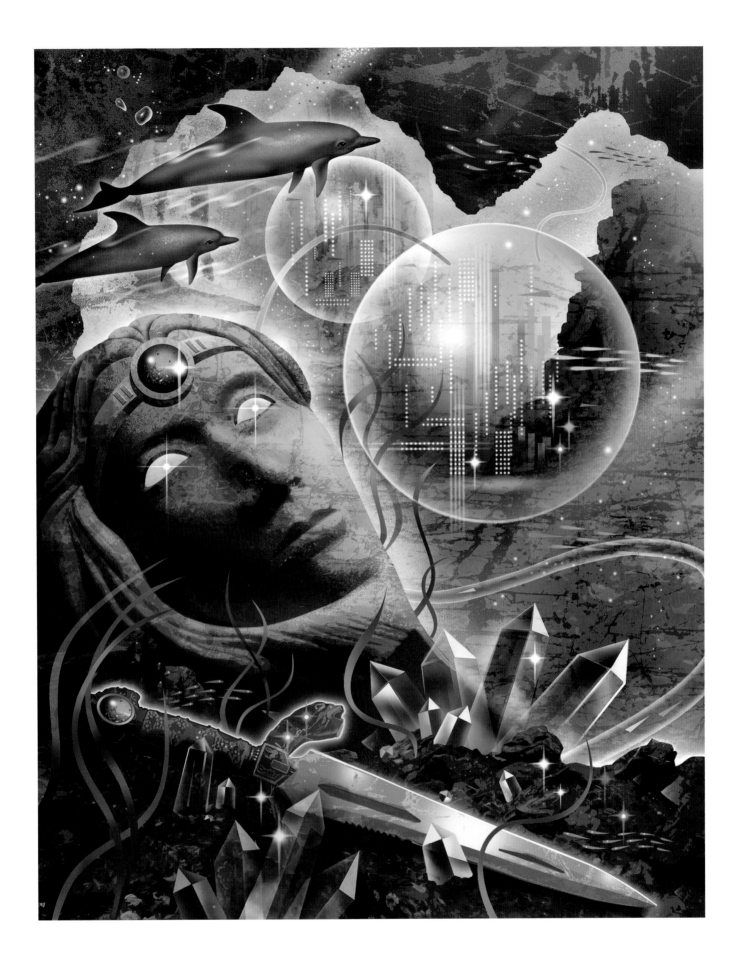

"LEGEND OF A LOST CITY" Created by Ron Oden. Copyright © 2006.

TEXTURE:
Marks of
Judgment

SOURCE:
Kaibeto Canyon,
Arizona (Navajo
Reservation)

After hiking into a remote canyon, I spotted this fascinating geological
formation that seemed to hearken from the days of Noah.

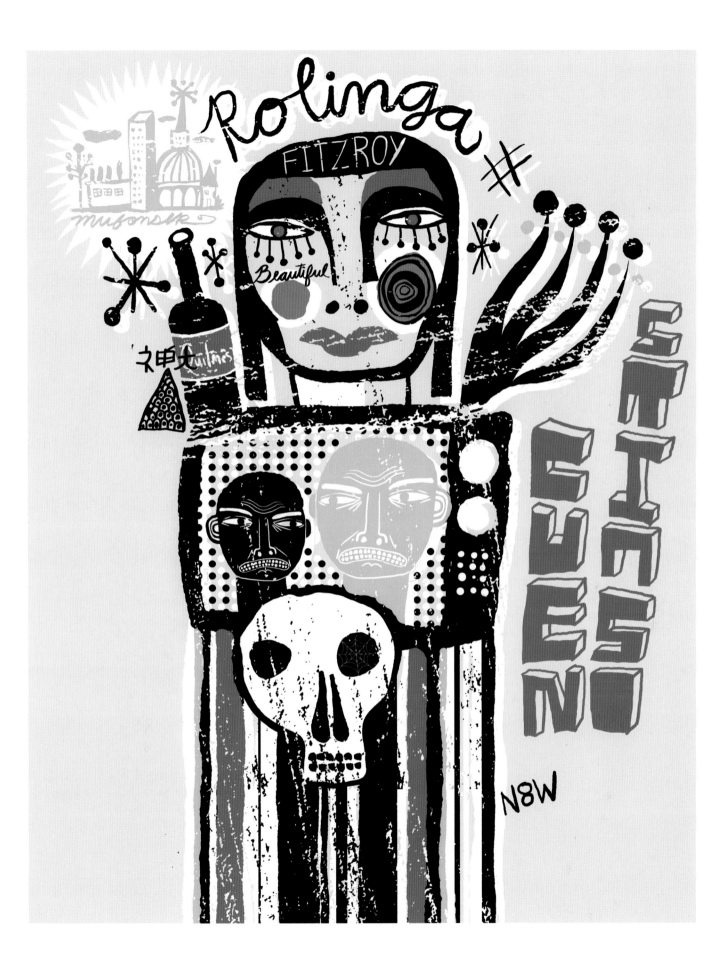

"ROLINGA" Created by Nate Williams. Copyright © 2006.

TEXTURE:
Black Box

SOURCE:
old chest

Sometimes you find the treasure outside the chest. Scuff marks, chipped paint and tarnish add mystery, depth and patina to this image.

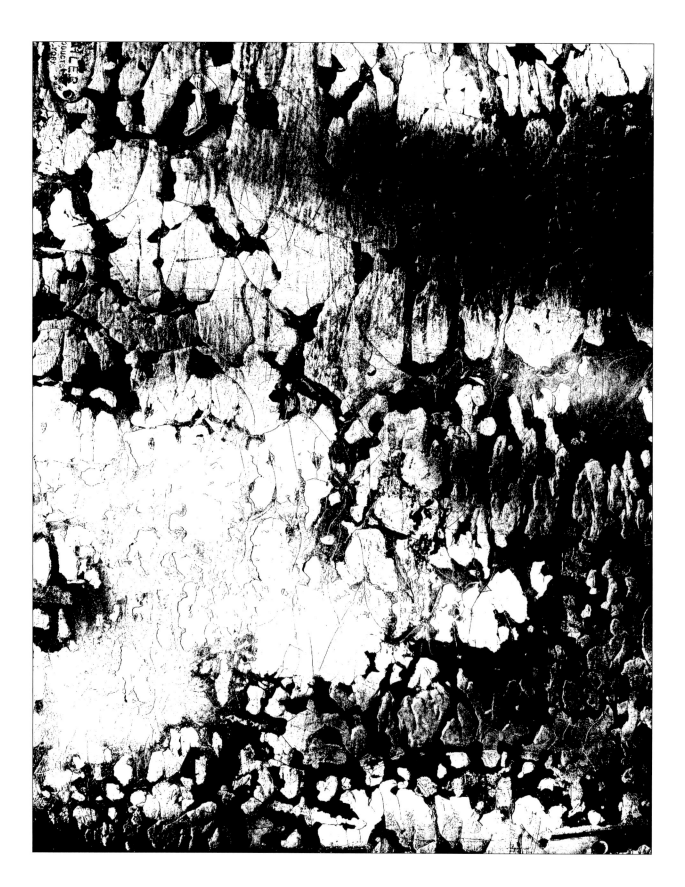

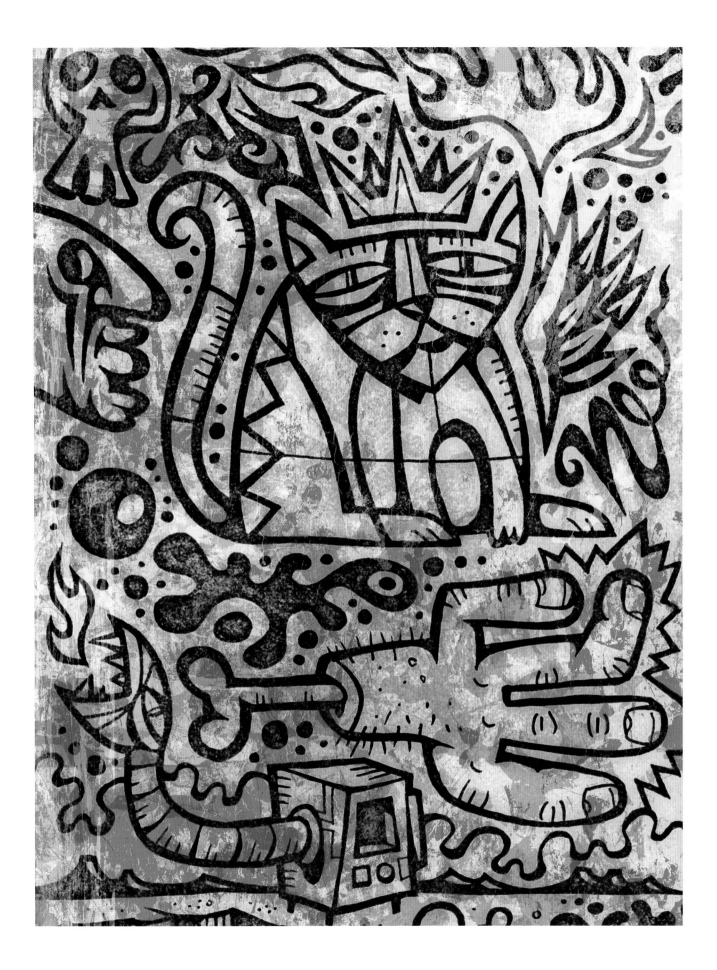

"IF THY HAND OFFEND THEE" Created by Von R. Glitschka. Copyright © 2006.

TEXTURE:
High Traffic

SOURCE:
speed bump

The tires of a few hundred thousand cars were the paintbrushes that turned this mundane speed bump into a work of art. I saw a van Gogh over it right after I took the photo.

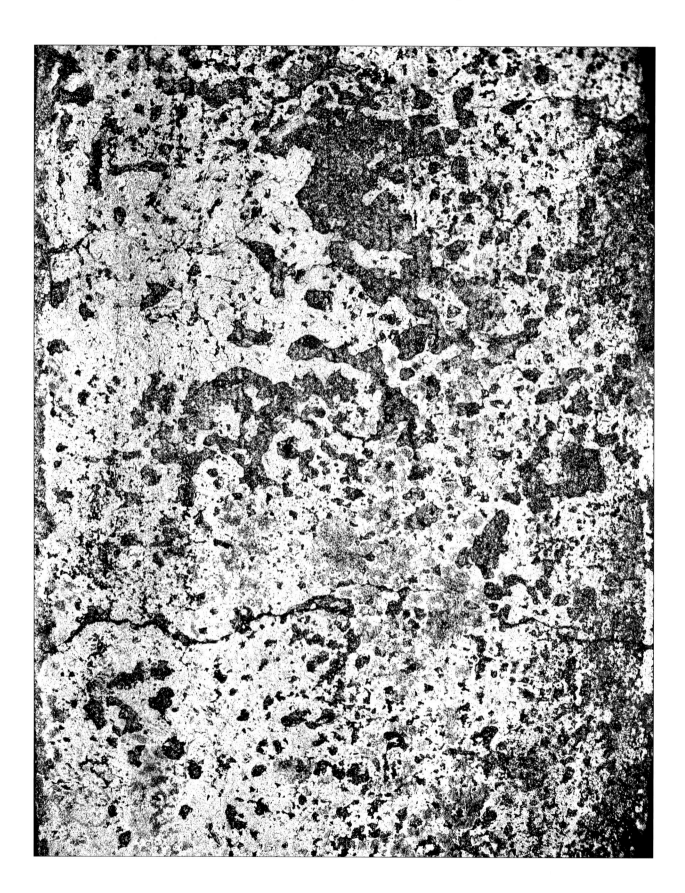

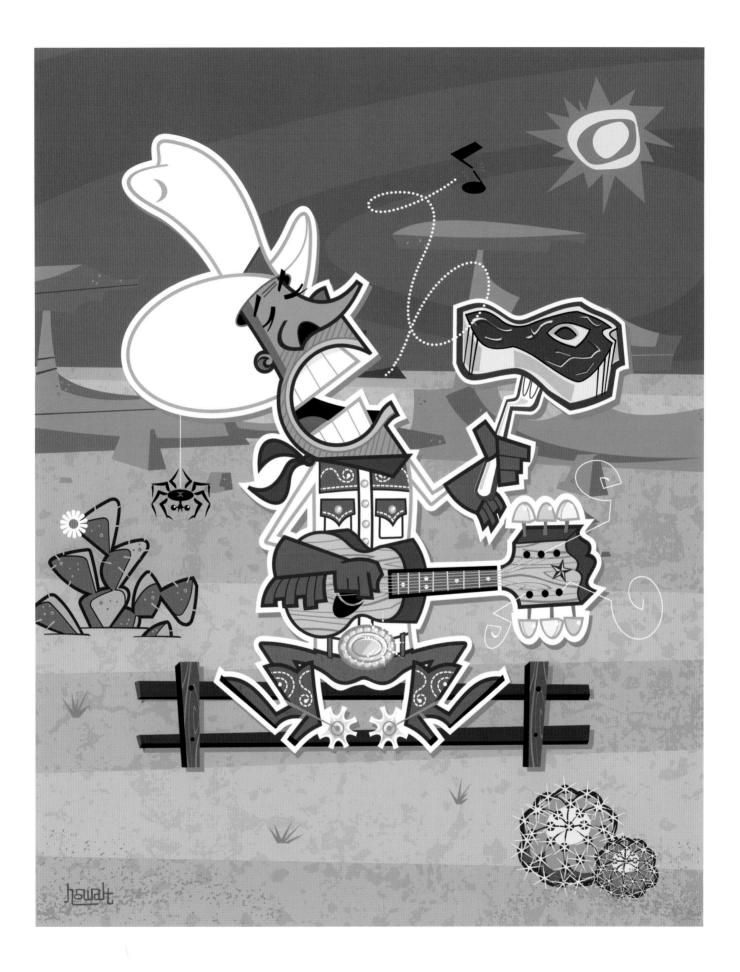

"THE BLOOMING DESERT" Created by Paul Howalt. Copyright © 2006.

TEXTURE:
Tortured Surface

SOURCE:
cement siding

Follow me down the winding stone stairs into the graphic dungeon, where this texture will torture your design surfaces. Muhahahah! (Insert fiendish laugh and raised evil eyebrows here.)

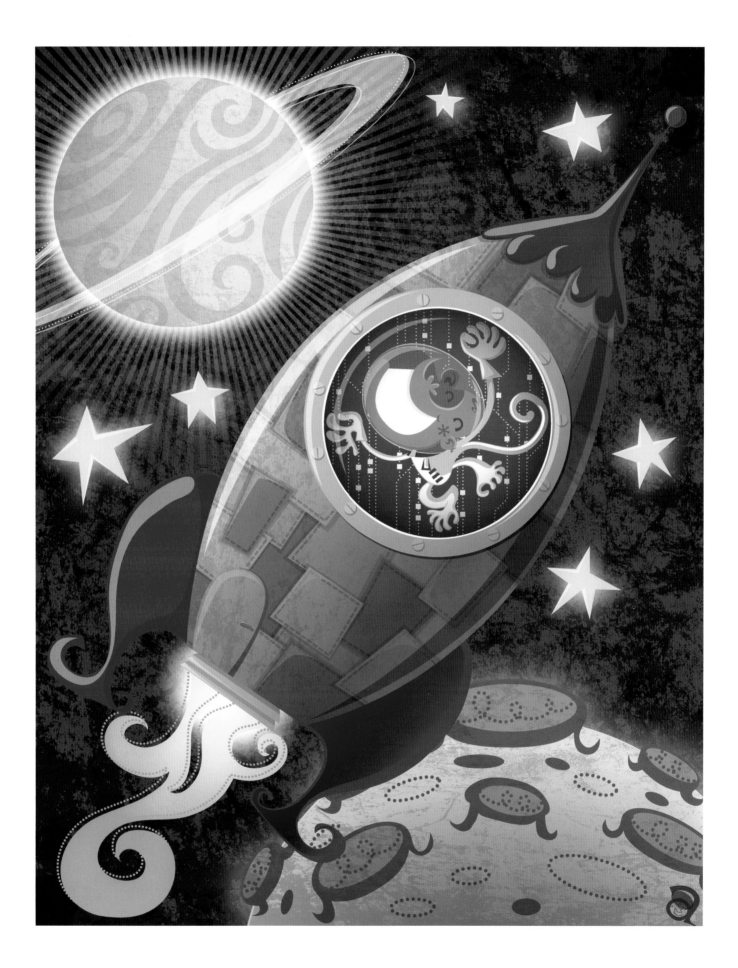

"LITTLE MONKEY IN OUTER SPACE" Created by Andi Butler. Copyright © 2006.

TEXTURE:
Cascading Decay

SOURCE:
railroad
retaining wall

A Niagara Falls of decrepit materials flows down the side of a railway embankment.

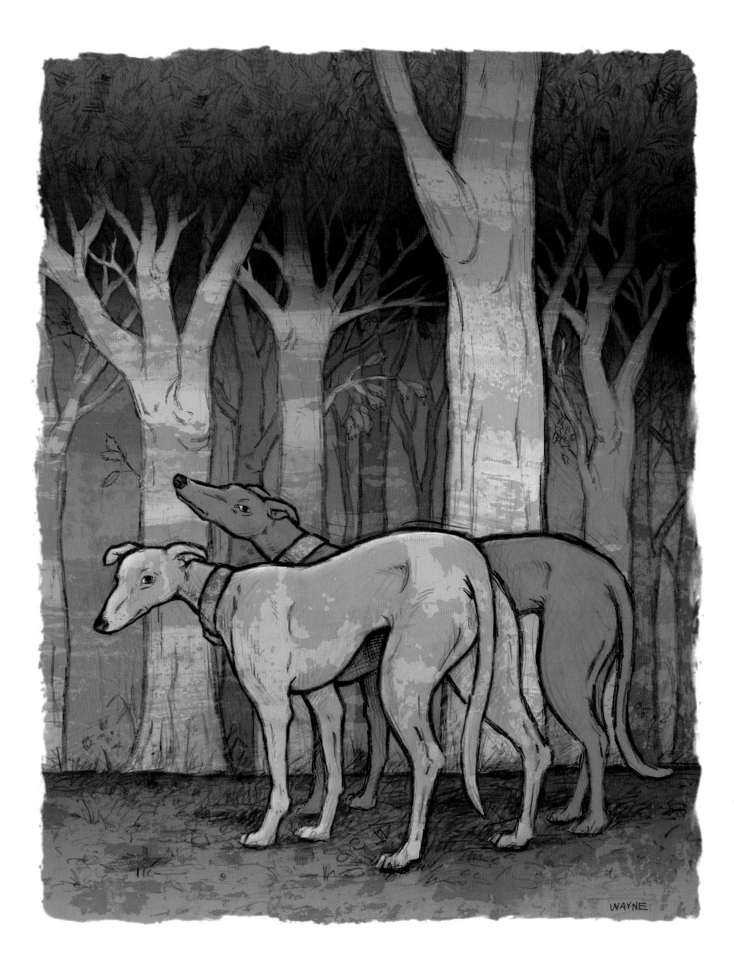

"HOUNDS IN A FOREST CLEARING" Created by Wayne Wilcoxen. Copyright © 2006.

TEXTURE:
Structural Leprosy

SOURCE:
support column

This ailing column is an engineer's worst nightmare, but it can be your dream come true, graphically speaking.

"ESKIMO PIE" Created by Greg Epkes. Copyright © 2006.

TEXTURE:
Parking Rot

SOURCE:
parking lot

A five-star recipe for delicious distress. Paint, pavement, cars and time are the only ingredients needed to create this texture. Sprinkle on a little dirt, maybe a handful of gravel ... and voilá, your artistic entrée is complete.

"SNACK TIME" Created by Drew Pocza. Copyright © 2006.

TEXTURE:
Crappy Crate

SOURCE:
antique milk crate

In simpler times, this old crate held glass containers filled with dairy products. Now you can milk it for all it's worth.

"SKELE-TIKI" Created by Carson Brown. Copyright © 2006.

TEXTURE:
Burn Victim

SOURCE:
metal cabinet

Let your creativity spark as you set your design on fire with this scorching image.

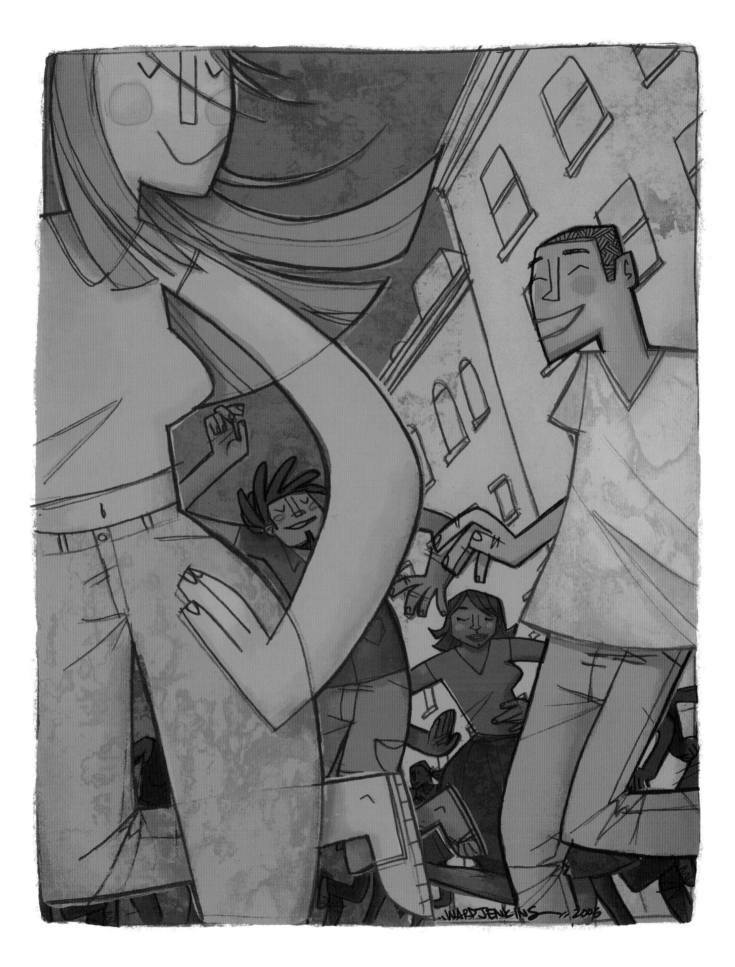

"STREET DANCE" Created by Ward Jenkins. Copyright © 2006.

TEXTURE:
Rust-O-Licious

SOURCE:
bulldozer siding

Scratched and scabbed, this heavy-duty machine continues to move earth despite a debilitating case of surface oxidation.

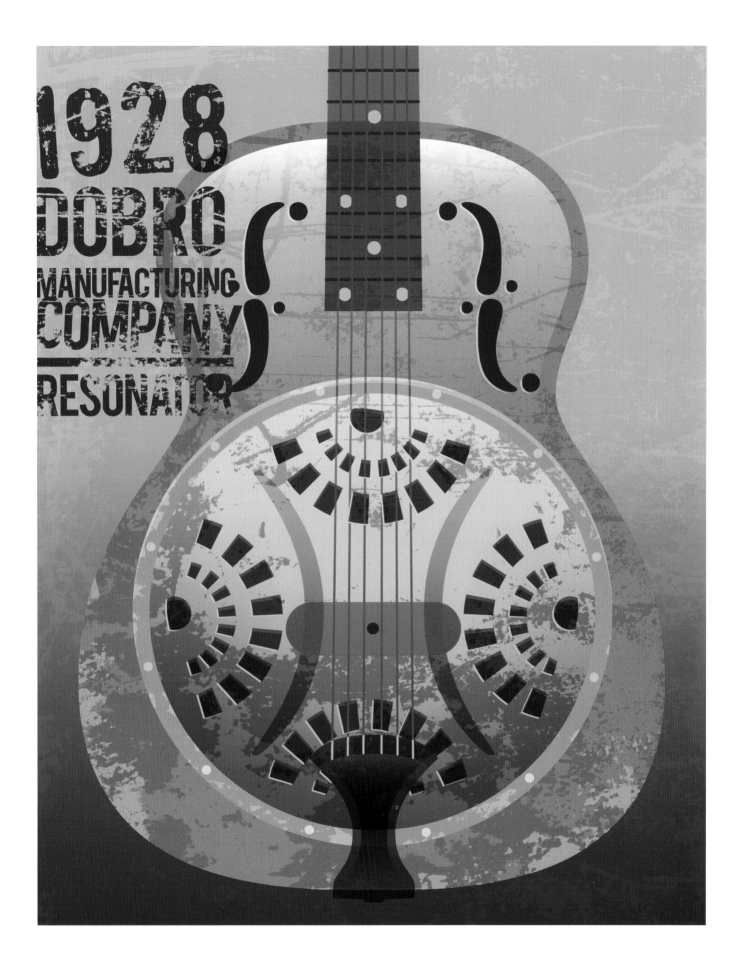

"**1928 DOBRO**" Created by Brent Pelloquin. Copyright © 2006.

TEXTURE:
Rock & Roll

SOURCE:
rock ledge

Crank up the stereo, break out the munchies and get "stoned" with this head-banging, hard rock image.

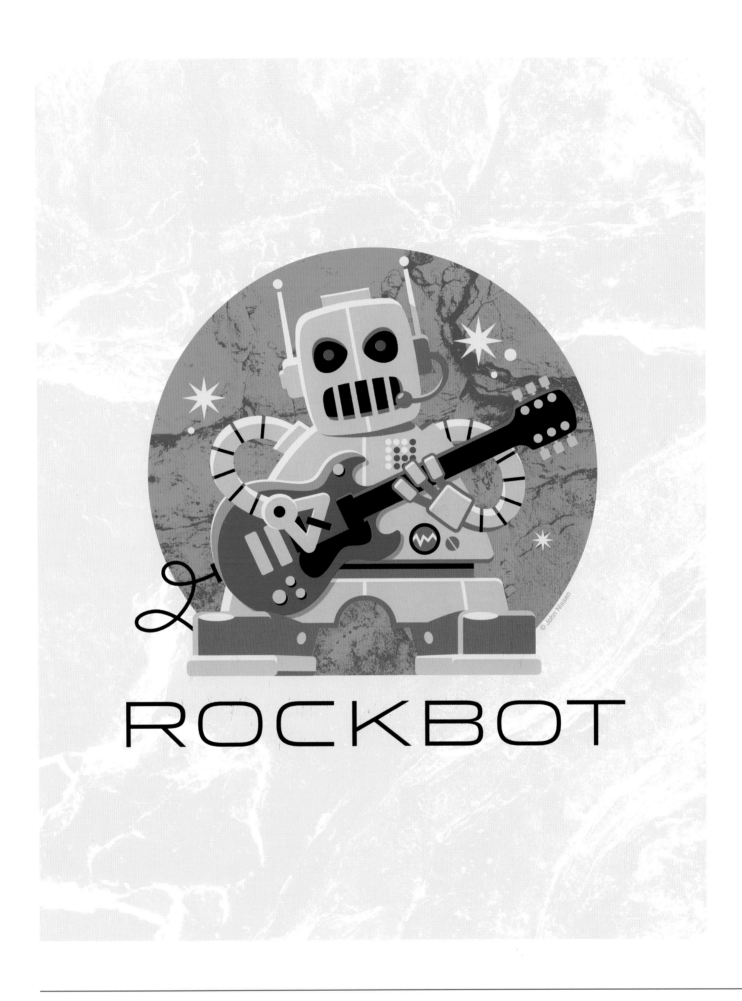

ROCKBOT

"ROCKBOT" Created by John Nissen. Copyright © 2006.

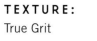

TEXTURE:
True Grit

SOURCE:
sandstone wall

While hiking, I stumbled upon this subtle but abrasive sedimentary texture. Like John Wayne's face, its weathered countenance seems etched by time and tribulation.

"TWELVE40NE.COM LOGO" Created by Von R. Glitschka. Copyright © 2006.

INDEX OF CONTRIBUTORS

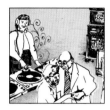